Tàpies

Antoni Tàpies

Ediciones Polígrafa

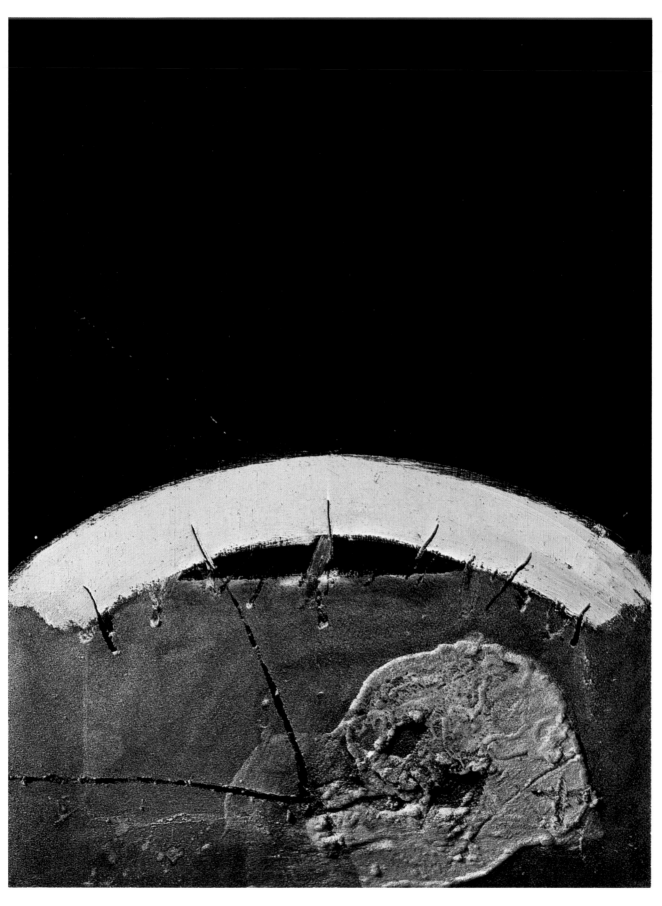

The Blue Arch, *1974.*
Mixed media on canvas, 116 × 89 cm.
Galerie Beyeler, Basel.

Tàpies' Œuvre in the Twentieth Century

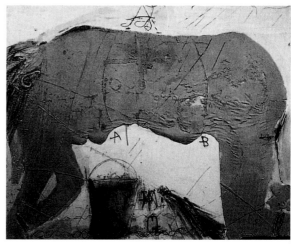

a. Nude, 1966.
Mixed media on canvas, 130 × 162 cm.

In his autobiography, Antoni Tàpies explains the circumstances that led him to create a new plastic vocabulary in the early fifties. As a result of his leftist political stance his main desire was to break away from the documentary or descriptive naturalism of Social Realism.

Despite being politically active at the time, Tàpies instinctively loathed the aesthetics of Stalinism, theorised in the USSR by Andrei Zhdanov and conscientiously applied in the West by many Communist artists. Yet he possibly felt an even greater loathing towards the abstract academicism and its falsely apolitical attitude that appeared as an alternative to so-called progressive art. In fact, Tàpies vehemently rejected what the critic Léon Degand termed "false abstraction" which consisted, hypocritically, of a stylised or disguised form of Naturalism. In France it was referred to as "Abstract Landscape Painting".

Tàpies' Alternative

Tàpies' art therefore developed by endeavouring to surmount the two ruses, taking the experimentation of visual perception of forms and colours much further, breaking with existing codes and dogmas and accepting "the unprecedented conflict that granted 'visibility' to what was supposedly conveyed."

Tàpies' art would escape geometry — albeit retaining some of its fundamental forms — in order to explore the world of organic life (fig. *a*), the 'amorphous', ambiguous and unfinished, the expressiveness of pure gesture inspired by Chinese and Japanese traditions.

Finally, the Catalan artist would make abundant use of certain materials, the natural force of which he had intended to explore from the earliest stages of his career in the forties. In 1954, by when he had attained a characteristic style of his own, a decisive event — his meeting with the French art critic Michel Tapié — was set to influence his life and work, for the following year Tapié introduced him to the Stadler gallery and in 1956 he wrote the first monographic study of the painter's œuvre.

Since then, Tàpies has conquered an original and essential position on the international art scene. A reader of Sartre and Heidegger, he has never yielded to the demands of what he calls a "non-genuine existence", to use the terms of his masters.

Authenticity as a Requirement

Two pictures, both of which have been acquired by the Parisian Musée National d'Art Moderne, sum up Tàpies' art perfectly. In point of fact, his art has not experienced variation over the years, gaining rather in depth. *Large Brown Triangle*, made in 1963 (fig. *b*), presents a simple shape that Tàpies, following his meditations on tantric painting, imbues with personal meaning. The upper part of triangle, which stands for fire and virility, is pierced by a horizontal shape possibly discovered by the artist in the wooden skeletons of the old houses he likes so much. Indeed, Tàpies combines a decidedly esoteric symbolism with a series of elements taken from everyday life. Among the latter, walls occupy a preferential place in his œuvre, and strangely enough in Catalan one of the words for 'wall' [*tàpia*] bears a close resemblance to the artist's surname.

The *Large Triangle* is a work that clearly belongs among Tàpies' matter paintings. The artist has mixed brown pigment with glue, sand and oil as his ground, on which he has traced a series of shapes by means of swift incisions into the thickness of the matter. Its austere monochromaticism inspires withdrawal and meditation for, as the painter tells us, it is an "interior colour" that stems from an "almost indefinable mystical œntiment indispensable to an artist".

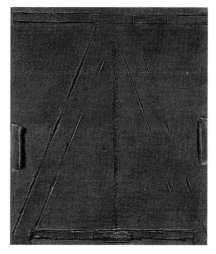

b. Large Brown Triangle, 1963.
Mixed media on canvas, 195 × 170 cm.

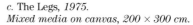

c. The Legs, 1975.
Mixed media on canvas, 200 × 300 cm.

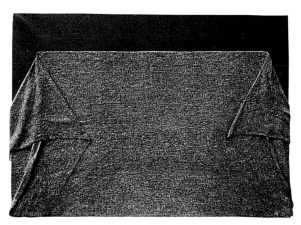

d. Grey Fabric, *1962.*
Paint and collage on canvas, 70 × 100 cm.

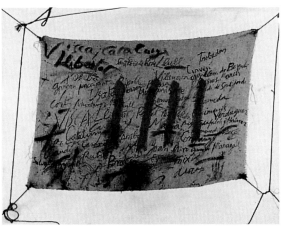

e. Inscriptions with Four Stripes on Burlap, *1971.*
Mixed media and assemblage on canvas,
55.9 × 62.2 cm.

f. Tibetan Bell, *1991.*
Colour lithograph, 120 × 79 cm.

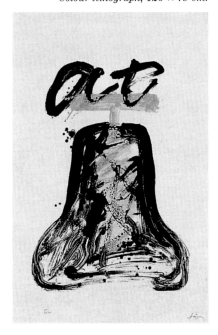

The Art of Collage

The second picture in the collection of the Musée National d'Art Moderne, painted in 1975, is entitled *The Legs* (fig. *c*) and belongs to the profuse set of collages of rudimentary objects and materials (straw, wood, old newspapers, cloths, etc.,). Tàpies had in fact begun to use all sorts of objects much before so-called Art Povera became an established trend (fig. *d*), yet his was not an 'anti-form' approach. On the contrary, he himself has clearly pointed out that the use of such materials evinces the "primeval naturalness of dialectics and of the struggle of all things, including of course the class struggle."

In *The Legs*, two pieces of wood arranged in the form of a cross hold a square of white cloth in place, which in turn is stuck onto two crudely cut-out legs. Above the figure appear spirals of black paint symbolising the winds of freedom soon to be blowing through oppressed Spain (Franco, still in power, would die that very year). This "paint, wood and cloth on canvas" measuring two metres by three, exemplifies the trajectory of a great painter whose key project is to make even the matter of painting legible, albeit challenging it through confrontation with a variety of strange elements (objects and writing).

A Personal and Political Painting

Other forms of contrasts are also present in Tàpies' œuvre. The deep grey colour in *Painting No. XXVIII* of 1955 for instance (fig. 9), evokes old walls with rough surfaces marked by the passing of time and severe weather conditions, yet at the same time it favours the materialisation of a vaguely cruciform mysterious orange-coloured shape. Other pictures inspired by actual walls present graffiti-like inscriptions in which Andreas Franzke sees "palimpsests of human passions", passions that resurface in paintings just as mediaeval images and texts reappeared, once the original manuscripts had been rubbed and cleaned, under the new writing traced by scribes. In this case, Tàpies regards wall images as reminiscences: recollections, particularly of the Spanish Civil War that broke out when the painter was thirteen and which left an indelible mark on him.

This political context is essential for the comprehension of Tàpies' works, for he has always conceived his painting as a personal and political undertaking. This explains the presence in the picture *Inscriptions with Four Stripes on Burlap*, made in 1971 (fig. *e*) of the four stripes of the Catalan national flag, alongside that of the 'palimpsests', the calls for freedom for the artist's homeland. Over forty names can also be distinguished in this painting, those of important figures for both Catalonia and for the artist, ranging from Ramon Llull to Joan Miró.

Another version of this same work entitled *The Catalan Spirit* and made in 1972 (fig. 41) constitutes a vigorous expression of the painter's political stance. The four red strokes that stand out over the deep yellow ground are surrounded by fingerprints, drips and trails of purple that remind us of blood. In addition to these patches of colour the artist seems to have made brisk incisions — slogans and political maxims — in the thick layers of paint, hence the fragmented sentences and odd words that appear next to dogmatic demands for Catalan independence. Antoni Tàpies reveals his profound originality as a genuine matter painter who refuses to give himself up exclusively to the delights of working with matter — painting necessarily entails conveying content, and in his case, content relates to his personal life as much as it does to his social and political commitments, all of which appear within an undeniable stylistic unity, at least until the year 1976. Following the death of Franco and Spain's apparently irreversible pledge to democracy, Tàpies was able to devote more time to specifically formal issues and to testing new pictorial procedures (fig. *f*), experiments that went so far as approaching Environmental Art. A new form of mysticism, not associated with politics, was now free to emerge.

Tàpies' artistic career would experience another culminating moment in 1990, when the foundation bearing his name opened to the public in Barcelona. Housed in a building designed by the architect Domènech i Montaner, a contemporary of Gaudí's, the Fundació Antoni Tàpies does not merely preserve the œuvre of the great Catalan painter but displays work by other artists, thus fulfilling Tàpies' desire to favour a clearer perception of the meaning of contemporary art.

Tàpies: His Universe and Discoveries

àpies' œuvre is the fruit of two essential encounters in the painter's trajectory: on the metaphysical plane, the thinking of Ramon Llull, and on the material plane, graffiti-covered walls (fig. *g*). Both have helped him forge his pictorial universe, giving rise to the diversity of his plastic discoveries.

g. Dominant Purple-Grey. To the Victims of the Vallès Disaster, *1962.*
Mixed media on canvas, 132 × 164 cm.

The Influence of Ramon Llull's Combinatory Art

At a relatively early stage in his career Tàpies decided to position his work in relation to four essential references: Ramon Llull, Jakob Boehme, Antoni Gaudí and Max Ernst. Ramon Llull (1232-1315), the universal mediaeval genius, theologian, philosopher, poet, missionary and scientist, is practically a national saint in Catalonia, whose work *Ars compendiosa inveniendi veritatem seu Ars magna et maior* was supposed to comprise the various branches of wisdom, granting men the ability to advance towards knowledge and truth as much as to compose poetry.

Under Llull's influence, Tàpies considered that painting was a way of reflecting on life and of helping the beholder to see what the artist had already seen, for, as he wrote in *La práctica del arte,* "a man devoid of images, of imagination and of the sensitivity required to trigger associations of ideas and feelings, will be unable to create anything." Llull resorted particularly to "figures of meaning", that is to say, to letters as a medium with which "to copy mental figures". In his treatise *Ars magna* he privileges seven geometric figures which he calls A, S, T, V, X, Y and Z.

These very letters appear in a number of works by Tàpies (fig. 43), whose favourite capitals are the A (the figure of essential dignities) and the T (that represents the principles of distinction of meaning). To Llull's seven figures, Tàpies adds the M (fig. *h*), the sign of will. The artist relates the letters A and T of course to his own initials, and to those of his wife Teresa. In 1986 Tàpies published a series of etchings dedicated to the Ramon Llull writings that had inspired a number of artists in the sphere of Surrealism, a movement Tàpies himself had been attracted to in the forties and fifties.

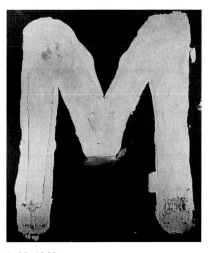

h. M, *1960.*
Mixed media on canvas, mounted on board, 195 × 170 cm.

The Wall Motif

Instead of isolating his figures, around the year 1952 Tàpies began to blend these into the pictorial ground, which was increasingly darkened by the use of charcoal and watercolour, especially in the case of works on paper and cardboard. These new grounds of dramatic appearance precede the first "images of walls" that emerge in the mid fifties (figs. 8, 9). At this time (Tàpies first visited Paris in 1950) the prevalent trend in the Parisian art world was clearly Matter Painting, as proven by the works of Wols, Fautrier and Dubuffet. Moreover, Tàpies had been very impressed by the photographs of walls produced at roughly the same time by Brassaï.

i. Earth on Canvas, *1970.*
Mixed media on canvas, 175 × 195 cm.

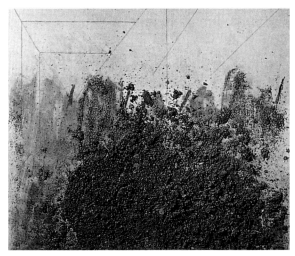

Catalan walls would soon appear in the work produced upon his return to Barcelona. This new stage in his painting is characterised by a lack of transparency and a combination of working procedures and techniques. Giving up the use of oils (fig. *i*), materials such as sand and marble powder enhance the material quality of image-objects in relief. From this point onwards, Tàpies would introduce all sorts of objects and materials into his pictures, natural and rough-hewn, matt and dense (never smooth or polished), their ambiguity prompting countless interpretations. As Tàpies himself has pointed out, "My works elicit various readings. However, I obtain far greater room for the associations I wish to awaken in the beholder by suggesting things […] I have realised that when things are merely insinuated in drawing, viewers are forced to resort to their own imagination in order to complete them."

Tàpies' excellence lies precisely in this talent for 'forcing' the viewer to continue and complete his œuvre.

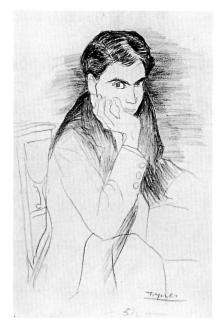

j. Self-Portrait, *1945.*
Pencil on paper, 49 × 34 cm.

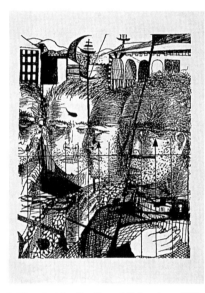

k. Drawing for the *Dau al Set* review, *1951.*

l. The Barbershop of the Damned and
the Chosen, *1950.*
Oil on canvas, 97 × 130 cm.

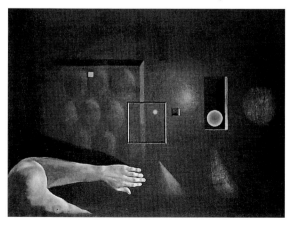

The Life of Antoni Tàpies

Selected Biography

1923 Antoni Tàpies is born in Barcelona on the 13th of December. His family is well learned (its members include book sellers and politicians), and attach great importance to Catalan tradition.

1926–1932 Tàpies is educated at a school run by the Loreto nuns, and at the German school in Barcelona.

1934 He discovers contemporary art thanks to a Christmas issue of the Catalan review *D'ací i d'allà*, which includes reproductions of works by Picasso, Braque, Gris, Léger, Mondrian, Kandinsky, etc., alongside an essay by Christian Zervos.

1936–1939 During the Spanish Civil War his learning is furthered at the Liceo Práctico secondary school, also in Barcelona, and he begins to draw and to paint.

1940–1943 His studies are interrupted on health grounds, and he is admitted to the Puig d'Olena nursing home to reco- ver from a lung complaint. Forced to rest, he copies pictures by Van Gogh and Picasso, and reads the works of Thomas Mann, Nietzsche, Stendhal, Proust and the German Romantics.

1944 At Barcelona University he begins law studies, which he will give up before completing his degree. During a two-month period he attends drawing lessons at the Valls art school in Barcelona.

1945 His activity focuses increasingly on painting, while he begins to read Jean-Paul Sartre and Heidegger and is drawn to Oriental philosophy.

1947 Tàpies begins to frequent poets and members of the Barcelona intelli- gentsia. One of these, the art critic Sebastià Gasch, publishes an essay on his drawings in the review *Destino*.

1948 He takes part in Barcelona's Salón de Octubre, and is a co-founder of the review *Dau al Set* (fig.*k*). Other fields of interest include Surrealism and psychoanalysis. He meets Joan Miró.

1950–1951 First solo exhibition at Galeries Laietanes in his hometown. A grant awarded by the French govern- ment enables him to travel to Paris, and during his sojourn there he will passio- nately follow the controversy surroun- ding Social Realism. He visits Picasso in his atelier on rue des Grands-Augustins.

1952 Tàpies is invited to exhibit at the Venice Biennial and at Pittsburgh's Carnegie Institute. Second one-man- show at Galeries Laietanes.

1953 First trip to New York on occa- sion of his exhibition at Martha Jackson. His participation in the São Paulo Biennial an acquisition prize.

1954 He takes part in the XXVII Venice Biennial and has another American exhi- bition at the Walker Art Center in Minneapolis. He marries Teresa Barba i Fàbregas.

1955 During another sojourn in Paris he meets the French critic Michel Tapié, thanks to whom he is invited to take part in the opening exhibition of the Stadler gallery.

1956 One-man show at Stadler. The exhibition catalogue is prefaced by Michel Tapié. Birth of his son Toni.

1957 Solo exhibitions in New York, Paris (Stadler) and Düsseldorf.

1958 He meets the poet and dealer Jacques Dupin, and takes part in the XXIX Venice Biennial, where he obtains the Unesco prize. Birth of his daughter Clara.

1959 Second New York exhibition at Martha Jackson. During his time there he meets Franz Kline, Robert Motherwell and Willem De Kooning. In Paris Michel Tapié publishes a mono- graph on his œuvre.

1960 Numerous exhibitions of his work are held all over the world. Birth of his son Miquel.

1961 Solo exhibition in New York and inclusion in group shows organised in different cities around the world, such

as *Arte e contemplazione* held at Palazzo Grassi in Venice.

1962 Retrospective exhibitions held at the Kestner Gesellschaft in Hanover, the Solomon R. Guggenheim Museum in New York and the Kunsthaus at Zurich.

1964 The III Dokumenta at Kassel devotes a gallery to Tàpies' works.

1965 Retrospective exhibition organised by Roland Penrose at the Institute of Contemporary Arts in London.

1966 The XV International Congress of Art Critics awards him a gold medal for the artistic and moral value of his œuvre. Tàpies begins to write his memoirs.

1967 He takes part in a number of group shows, including *Dix ans d'art vivant*, organised by Fondation Maeght at Saint-Paul de Vence.

1968–1969 Exhibitions continue to be organised worldwide.

1970 Tàpies creates a significant number of object-sculptures (fig. *m*).

1972 He receives the Rubens prize on occasion of the retrospective show held at Städtische Galerie im Haus Seel, Siegen (Germany).

1973 A retrospective show of his work is organised by the Musée d'Art Moderne de la Ville de Paris.

1974–1975 The British Arts Council awards him a prize for his engraving.

1976 Fondation Maeght at Saint-Paul de Vence holds another retrospective show of his work.

1977 North America welcomes a travelling retrospective exhibition.

1978 Tàpies publishes his autobiography.

1979 He is made an Honorary Member of the Arts Academy in Berlin.

1980 The Museo Español de Arte Contemporáneo in Madrid holds a retrospective show of his œuvre.

1981 His first ceramic sculptures are displayed at Saint-Paul de Vence. The artist spends some time in New York on occasion of his exhibition at Knoedler Gallery.

1982 His third volume of articles and statements is published under the title *La realidad como arte*. A retrospective exhibition is held within the Venice Biennial.

1983 His monumental sculpture *Homage to Picasso* (fig. *n*).

1984 His ceramics are displayed in Zurich.

1985 The book of Ramon Llull with illustrations by Tàpies is published.

1986 Rudi Fuchs organises a retrospective show of works in Vienna.

1988 Tàpies is named Commandeur dans l'Ordre des Arts et des Lettres by the French government.

1989 A retrospective show of his engraving is presented in Beijing.

1990 The large-scale sculpture *Núvol i cadira* is unveiled, crowning the Fundació Antoni Tàpies building in Barcelona. The artist travels to Tokyo, where he is awarded the Imperial Prize.

1994 An exhibition is organised by Musée du Jeu de Paume in Paris.

1995 The fourth volume of his *Catalogue raisonné* is published. A retrospective show of his prints is held at New York's Museum of Modern Art.

2001 In Paris the Bibliothèque Nationale de France holds an exhibition of his prints entitled *Tàpies ou la poétique de la matière* (fig. *o*).

2002 He is awarded the National Prize for Engraving and Graphic Art by Calcografía Nacional and the Real Academia de Bellas Artes de San Fernando in Madrid.

2003 Tàpies receives the Velázquez Prize for the Fine Arts, awarded by the Spanish Ministry of Education and Culture.

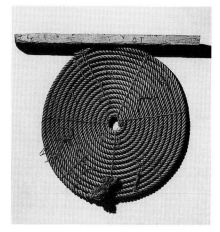

m. Spiral of Rope, *1972.*
Assemblage of glue, thread and board,
106 × 124 cm.

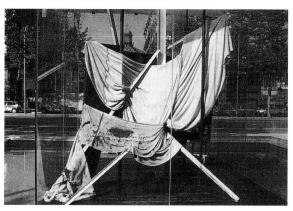

n. Homage to Picasso, *1983. Barcelona.*

o. Exhibition of prints at the Bibliothèque Nationale de France: Facsimile of the cover of the catalogue Tàpies ou la poétique de la matière, *2001, published by Éditions Cercle d'Art.*

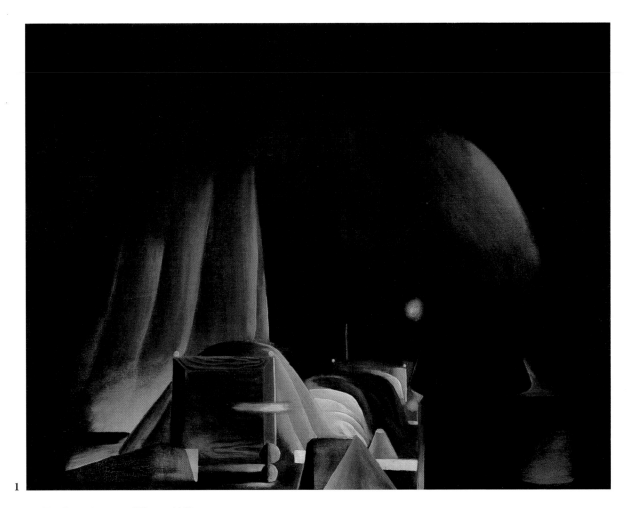

1 The Legerdemain of Wotan, *1950.*
Oil on canvas, 89 × 116 cm.
Private collection, Barcelona.

Influence of Dada and Surrealism

In his youth, Tàpies' œuvre was inspired by Surrealism and avant-garde French writers such as Arthur Rimbaud, although the artist made no attempt to meet André Breton and his circle of artists and poets on his first trip to Paris.

These influences can be traced in his work throughout the forties and fifties, as proven by the importance he attached to Rimbaud's notion of 'illumination.' "I use 'illumination' in the sense in which it is employed in the East, as the transcendence of the spirit. Rimbaud's writings do not only embrace the idea of illumination but also that of the 'alchemy of words,' which I find even more surprising, and which betrays the poet's chief obsession and his propensity for the occult, equally present at the root of avant-garde art and poetry."

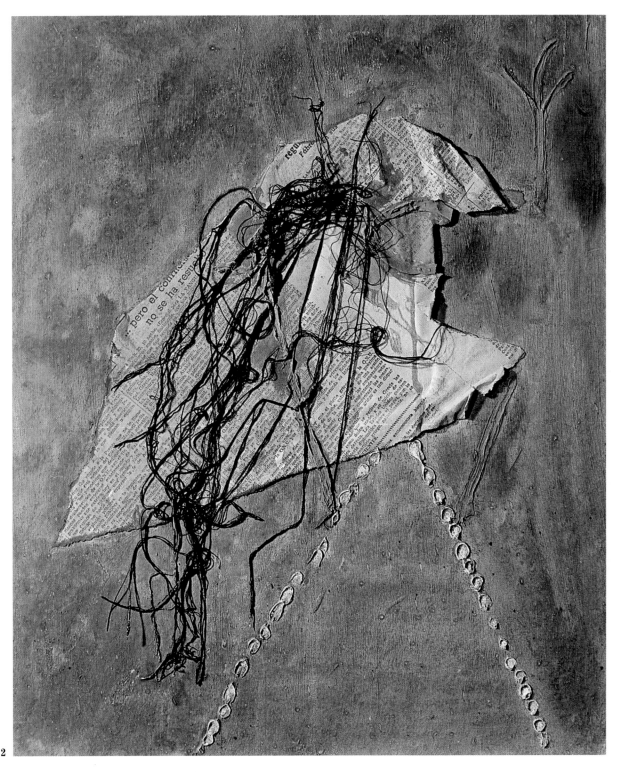

2 Figure of Newsprint and Threads, *1946.*
Paint and collage on cardboard, 46 × 38 cm.
Private collection, Barcelona.

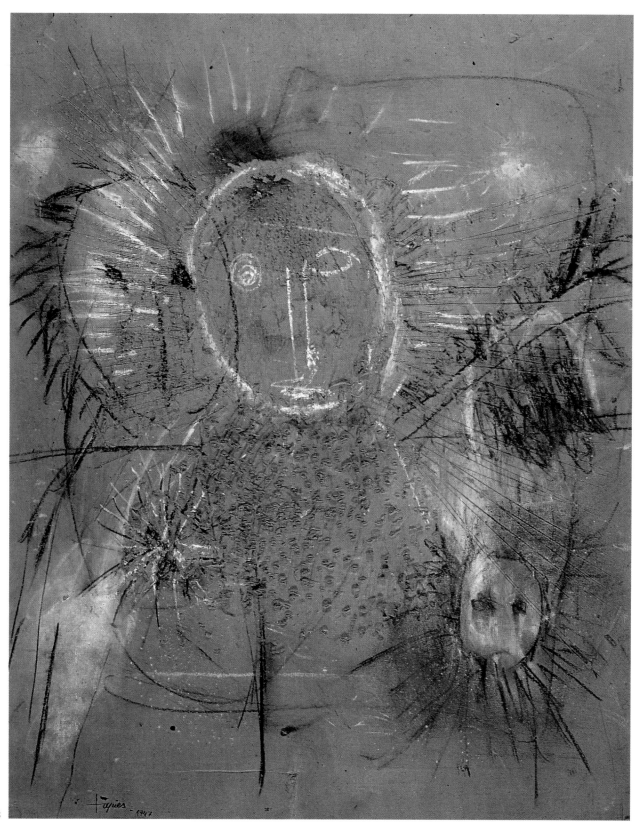

3

3 Grattage on Cardboard, *1947.*
Charcoal and grattage on cardboard, 91 × 73 cm.
Galerie Beyeler, Basel.

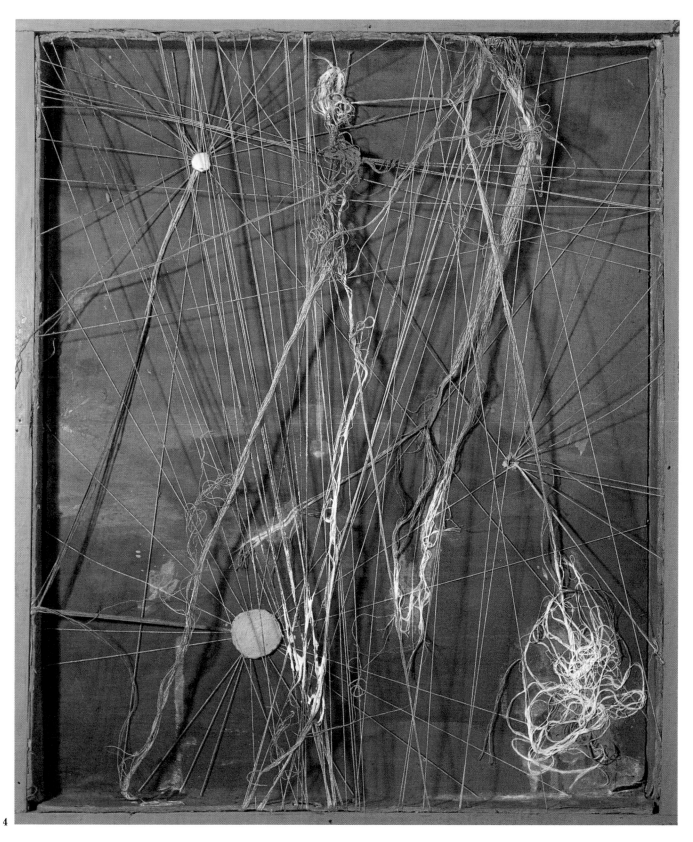

4

4 Box of Strings (front), *1946.*
Mixed media on cardboard, 48 × 40 cm.
Fundació Antoni Tàpies, Barcelona.

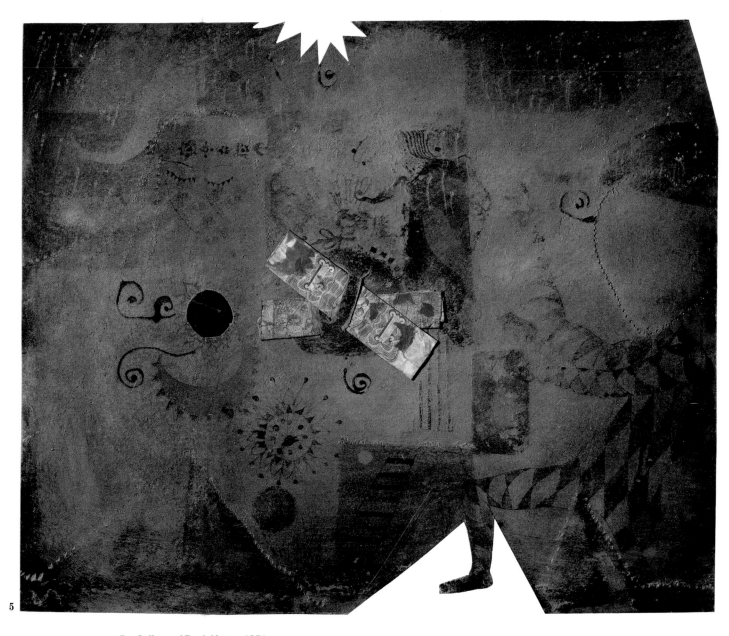

5 Collage of Bank Notes, *1951.*
Mixed media on paper, 26 × 31.5 cm.
Private collection, Barcelona.

*In these works, Tàpies combines the Surrealist influence
with that of Paul Klee, endeavouring to reconcile chance
with a conscientious organisation of compositional space.
The idea of placing real bank notes in the middle of the
picture could be interpreted as his personal protest
against the close links between art and money, as well as a
reference to the Cubist collages of Braque and Picasso.*

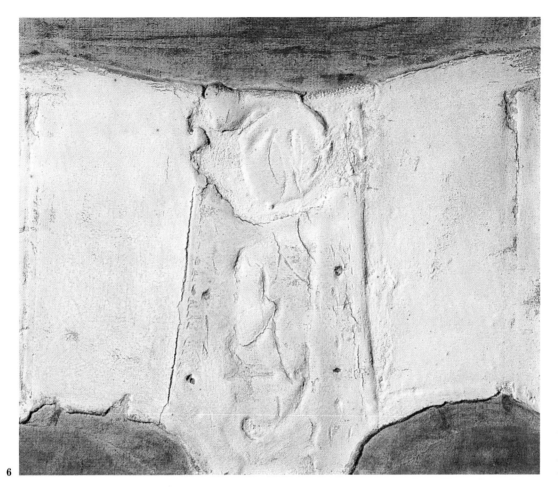

6 White Relief, 1959.
Mixed media on canvas,
46 × 54 cm.
Private collection,
Barcelona.

6

Matter Painting

After confessing his "disgust with the two prevailing trends in the art world" (Social Realism and the Abstraction of the School of Paris), in 1952 Tàpies decided to resume his experiments of the forties, producing intuitive works which while referring back to Oriental philosophy (yoga, Vedanta, Taoism, Zen) directly tackled matter in order to introduce it into his compositions. "At that time my paintings became true battlefields of experiment and I frantically put all my efforts into transforming materials [...] Destruction, in my paintings, eventually led to a static lull."

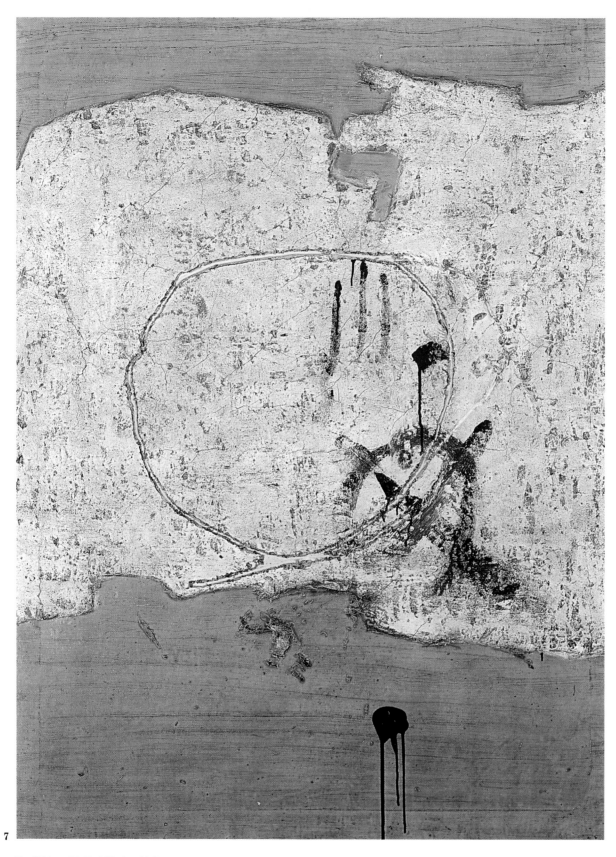

7

7 White with Red Marks, *1954.*
Mixed media on canvas, 116 × 88 cm.
María Luisa Lacambra, Widow of
Samaranch Collection, Barcelona.

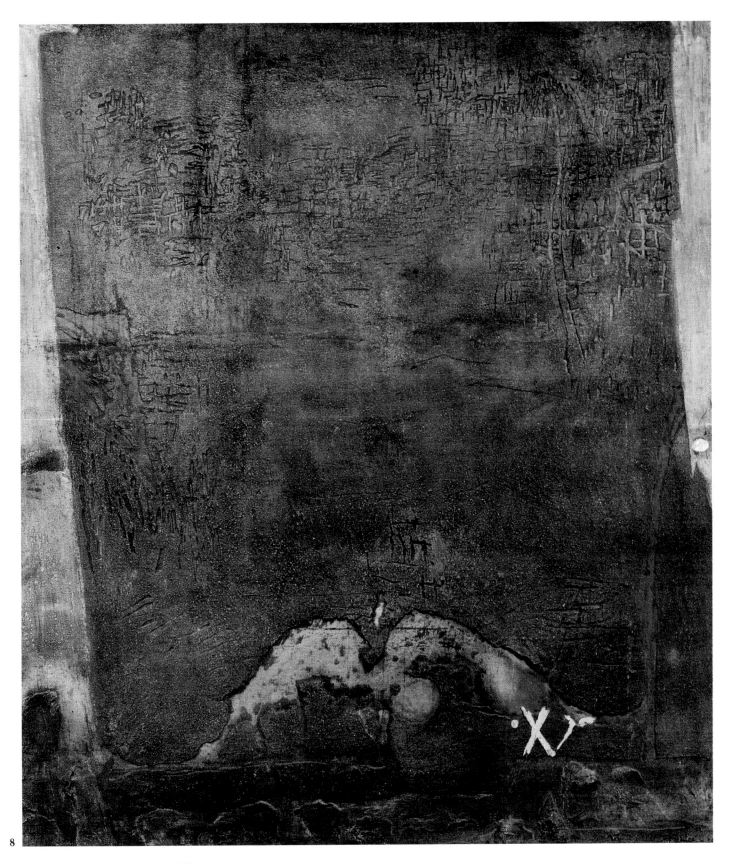

8

8 Large Grey Painting No. III, *1955.*
Mixed media on canvas, 194.5 × 169.5 cm.
Kunstsammlung Nordrhein-Westfalen, Düsseldorf.

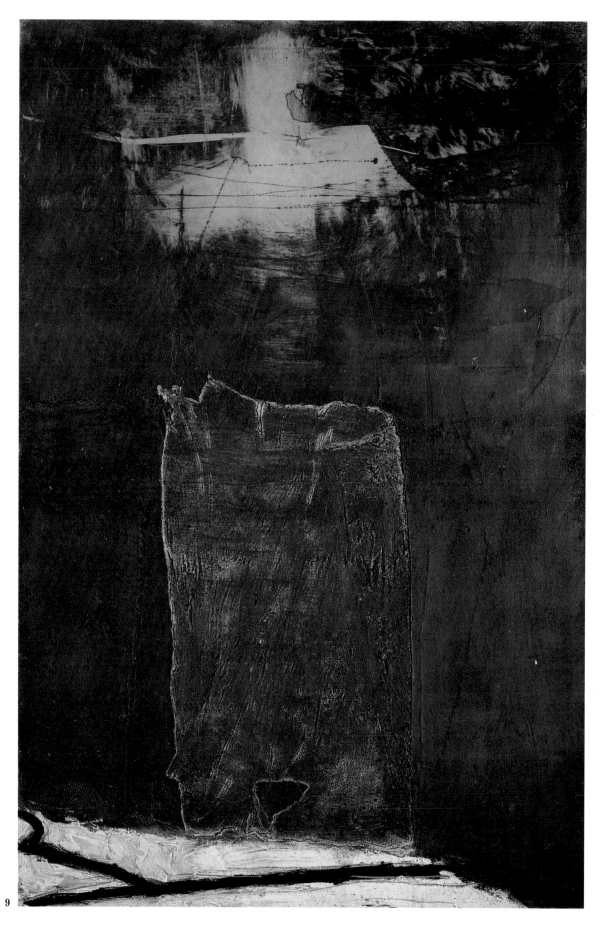

9 Painting No. XXVIII, *1955.*
Mixed media on canvas,
195 × 130 cm.
Private collection, Paris.

Tàpies plays with the
contrast produced
between two different
matter effects: on the
one hand, a bright
thick rectangular
shape, and on the
other, a thinner ground
illuminated by an
underlying layer of
intense orange. The
artist creates a double
impression of mystery
and absolute simplici-
ty, verging on the idea
of alchemy: "the sci-
ence of essences and
their origins [...],
artists turn to this
science to express
abstraction and to
stress contradictions."

9

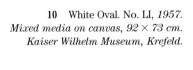

10 White Oval. No. LI, *1957.*
Mixed media on canvas, 92 × 73 cm.
Kaiser Wilhelm Museum, Krefeld.

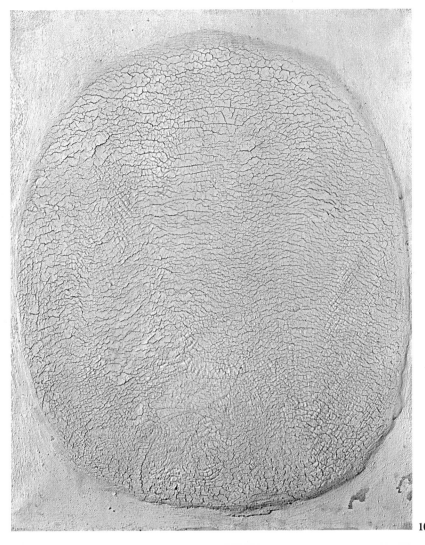

10

11 All White with Arcs, *1960.*
Mixed media on canvas, 146 × 114 cm.
Private collection, Barcelona.

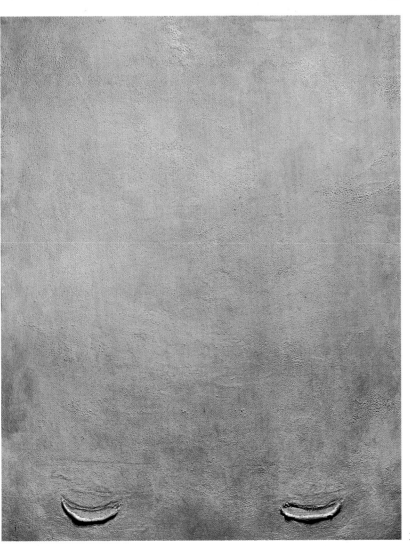

11

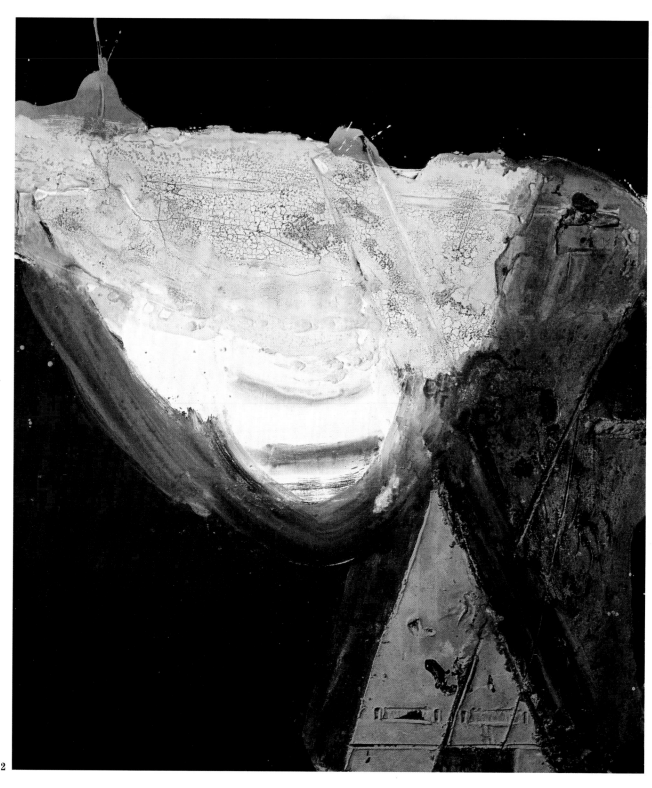

12

12 White and Ochre on Brown, *1961.*
Mixed media on canvas, 199.5 × 175 cm.
Private collection, Barcelona.

*In the early sixties Tàpies began to combine geometric
shapes he inscribed into the pictorial matter (in this case
a triangle) with flowing Expressionist gestures, which at
the time were associated with procedures employed by
Soulages and Franz Kline.*

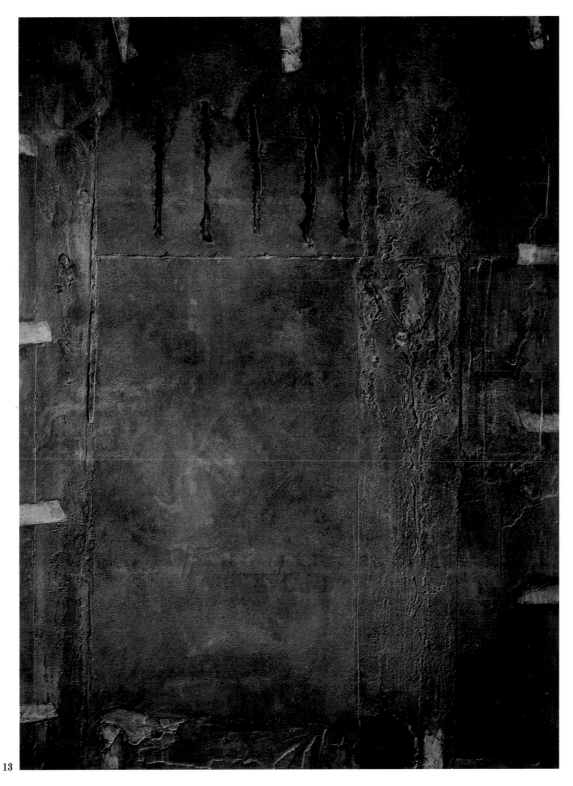

13

13 Large Matter with Lateral Papers, *1963.*
Mixed media on canvas, pasted onto wood, 260 × 165 cm.
Private collection, Barcelona.

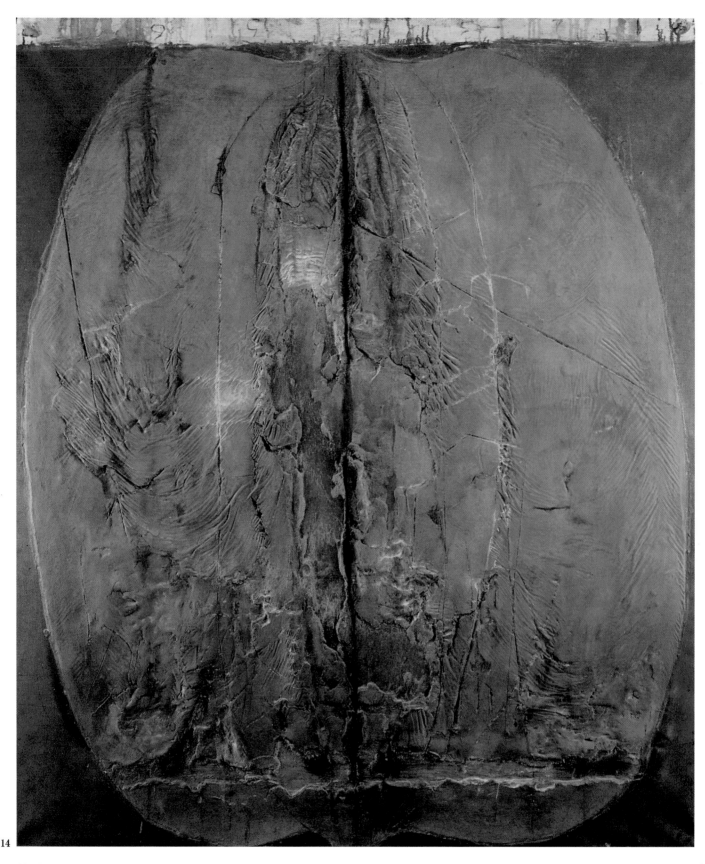

14

14 Matter in the Form of a Nut, *1967.*
Mixed media on canvas, 195 × 175 cm.
Private collection, Cologne.

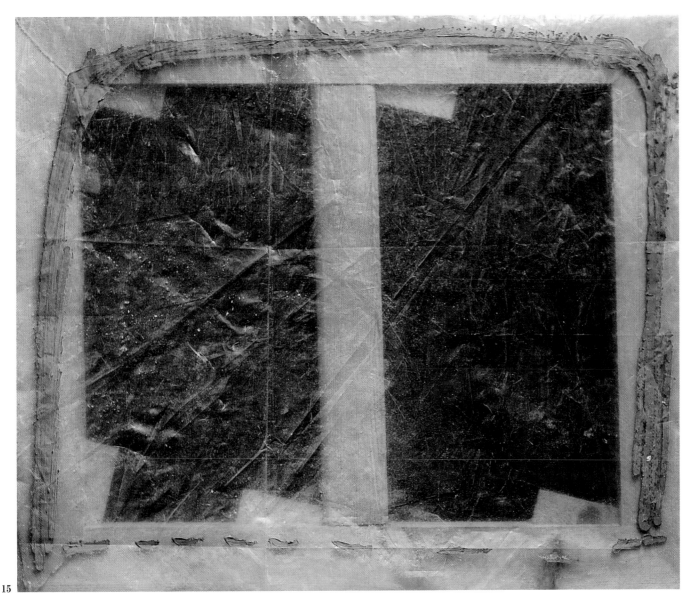

15

15 Frame Covered with Plastic, *1968.*
Paint and assemblage on back of canvas, 46 × 55 cm.
Private collection, Barcelona.

Tàpies extends his interest in matter to the very presentation of the
stretcher ('support') of the canvas, transformed into a parody of the
pictorial surface, covered in a film of transparent plastic matter
hurriedly surrounded by blue ('surface'). Such works seem to coincide
with those carried out at the same time in France by the
Supports/Surfaces group of artists, the main difference between the two
areas of experimentation being the Catalan artist's complete lack of
interest in Minimalism.

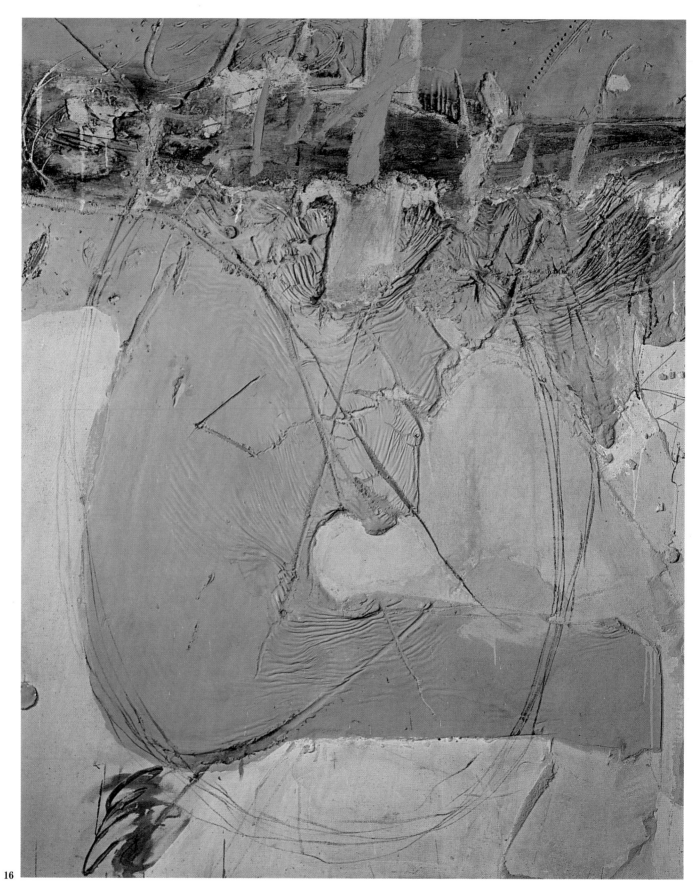

16 Body of Matter and Orange Marks, *1968.*
Mixed media on canvas, 162 × 130 cm.
Private collection, Barcelona.

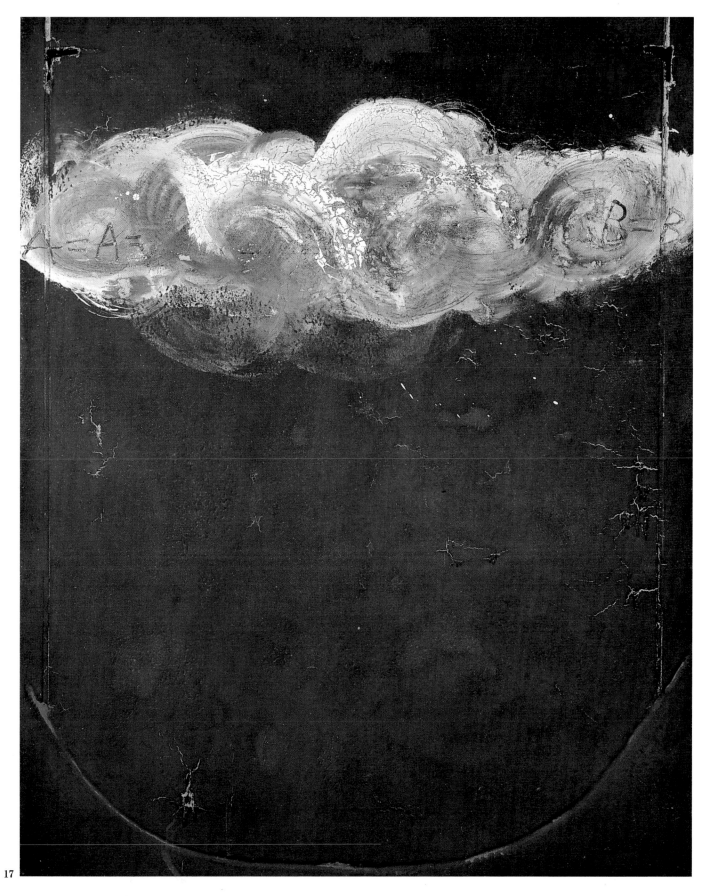

17 Emblematic Blue, *1971.*
Mixed media on wood, 162 × 130 cm.
Fundació Antoni Tàpies, Barcelona.

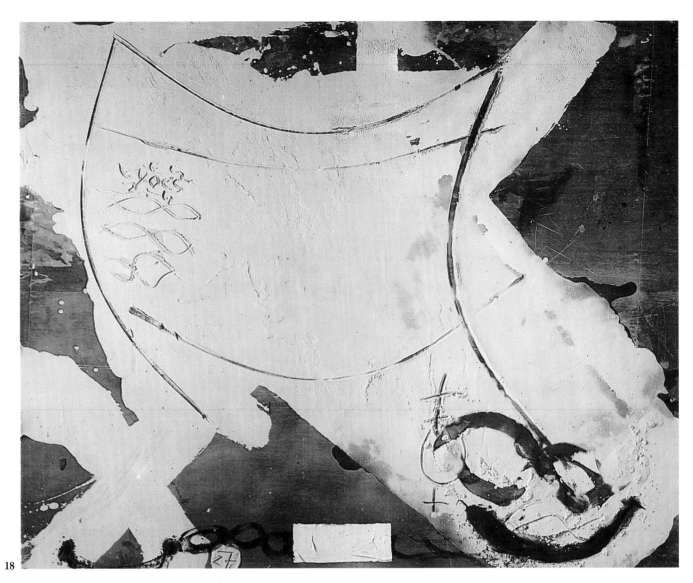

18

18 Curved Forms, *1980.*
Mixed media on wood, 220 × 270 cm.
Private collection, Valencia.

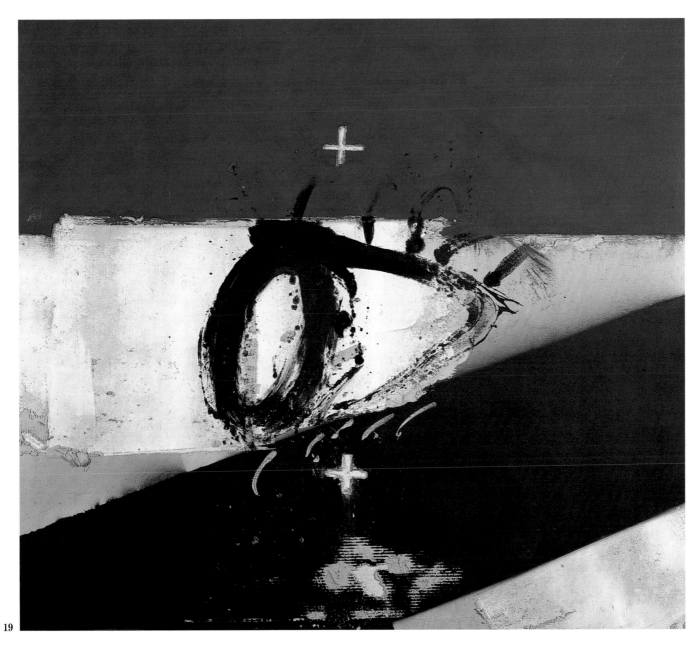

19 Red and Black, *1981.*
Mixed media on wood, 170 × 195 cm.
Private collection, Fort Worth, Texas.

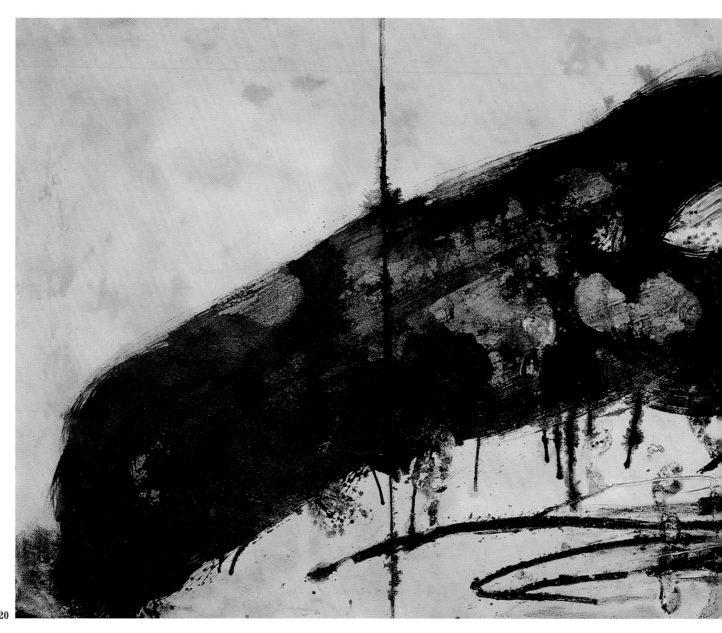

20

20 Large Knot, *1982.*
Mixed media on wood, 200 × 500 cm.
Fundació Antoni Tàpies, Barcelona.

*This large diptych (measuring five metres in length) is
a synthetic work in which Tàpies renders with
admirable authority his conception of art as a means of
reconciling opposing forces. The two poles on which the
artist constructs the painting are the colours black and
white, on the one hand, and impulse and reason, on the
other. Thus, the large dark shape that covers the two
areas of the work is depicted on a thick clear ground that
presents a number of enigmatic signs. This shape can be
read as impulse, yet it obeys the order imposed by the
artist's will, symbolised by two figures (1 and 2).*

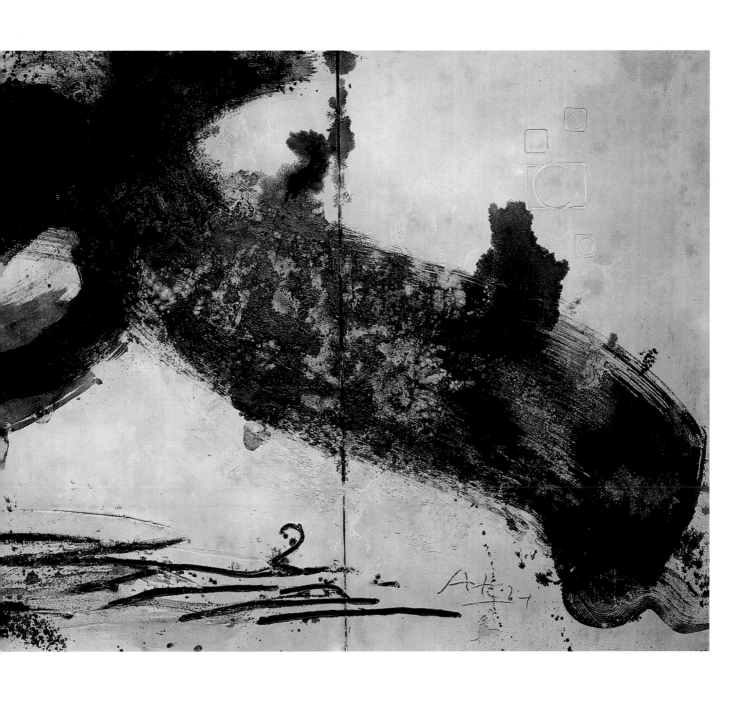

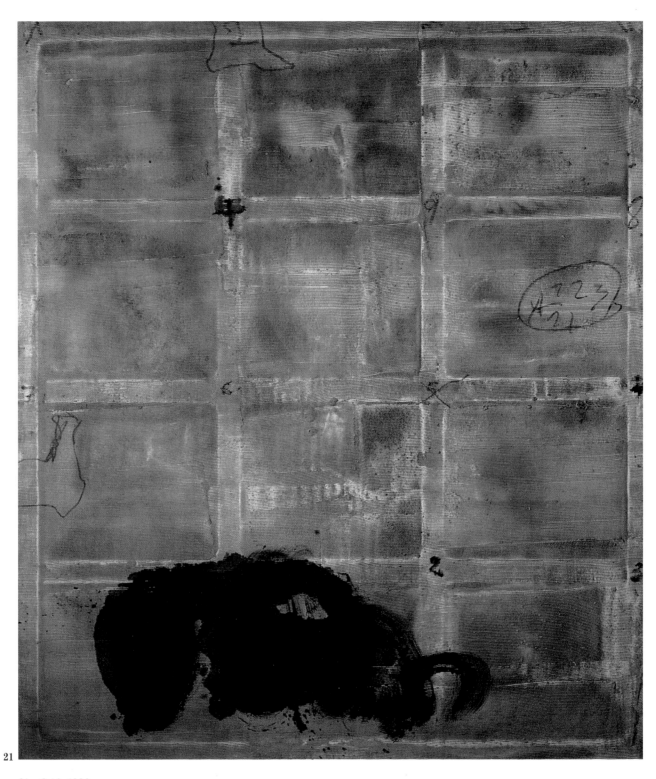

21

21 Grid, *1986.*
Mixed media on canvas, 195 × 170.5 cm.
Private collection, Geneva.

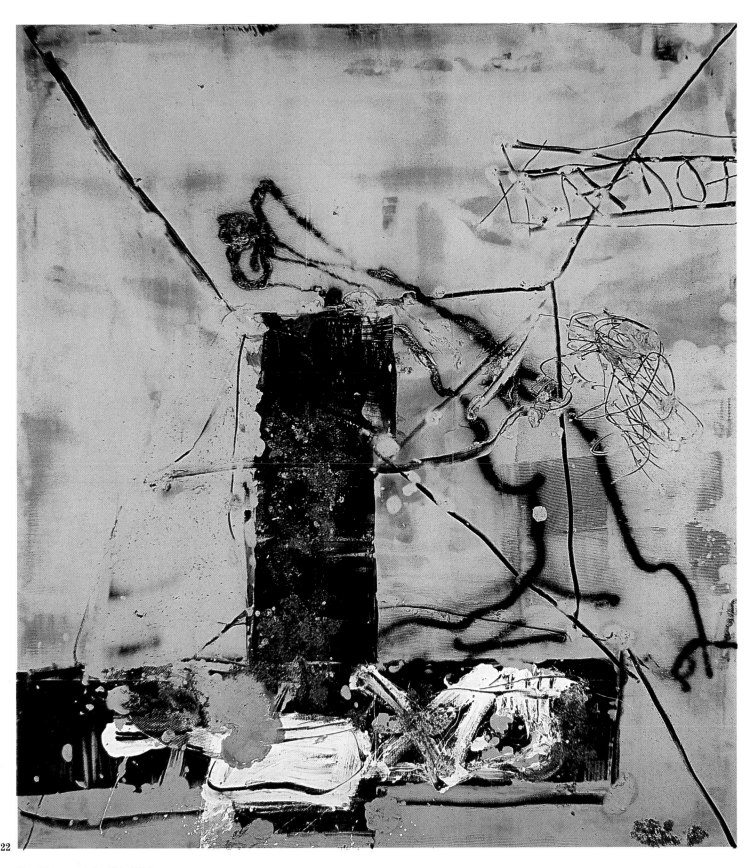

22

22 Matter and Graffiti, *1986.*
Mixed media on wood, 275 × 250 cm.
Fundació Antoni Tàpies, Barcelona.

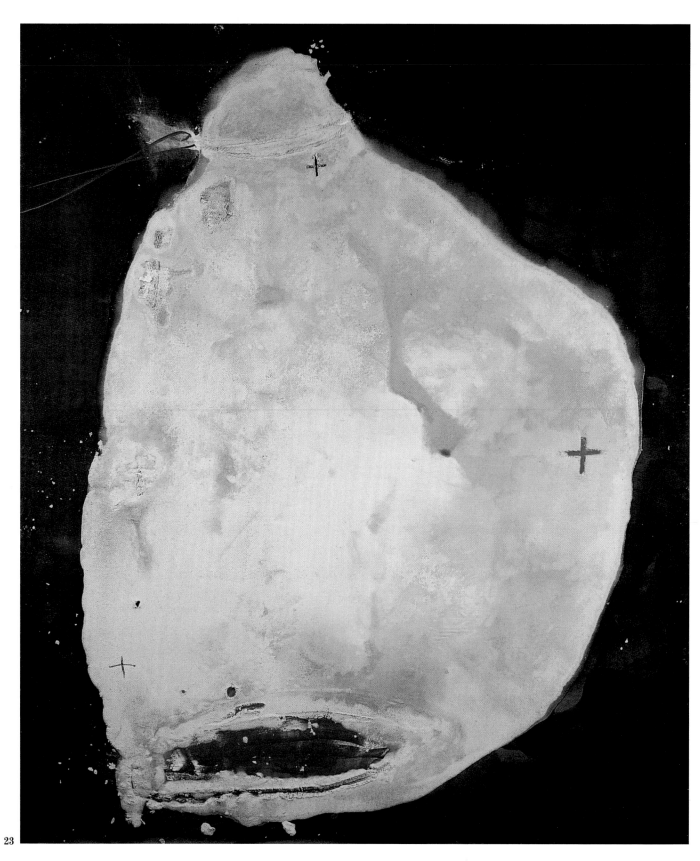

23

23 Large Material Form, *1988.*
Mixed media on wood, 300 × 250 cm.
Zia Fine Art Inc., Tortola, British Virgin Islands.

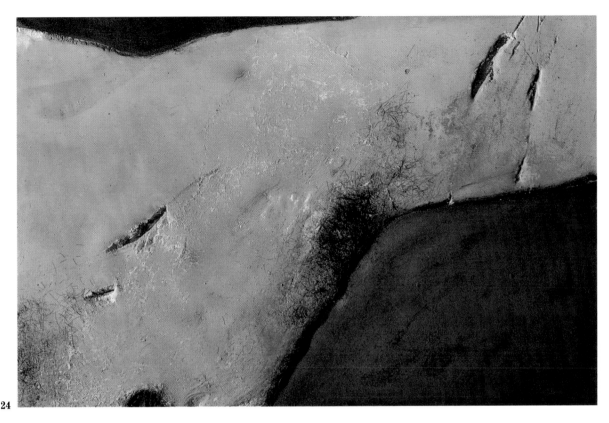

24

24 Matter in the Form of an Armpit, *1968.*
Mixed media on canvas, 65.5 × 100.5 cm.
Private collection.

The Persistence of Figures

Apart from the works produced during his early years, the human
figure is absent from Tàpies' œuvre, replaced by signs or 'icons' (that is
to say, magical images) often linked to material fragments such as a
piece of cloth, a rope or a sponge. In those works in which the figure is
not apparent however, it is still evoked through perfectly visible traces.
According to the artist, this "could also be related to my determination
never to resume painting as a form of photographic reproduction. I am
not interested in all that is susceptible of being photographed. I
endeavour to invoke the human being indirectly, resorting to traces or
to parts of the human body. Many of my paintings present only an arm,
a hand or an armpit. I have even gone so far as to seek those areas of
the body that are considered to be less noble in order to prove that they
are all equally respectable."

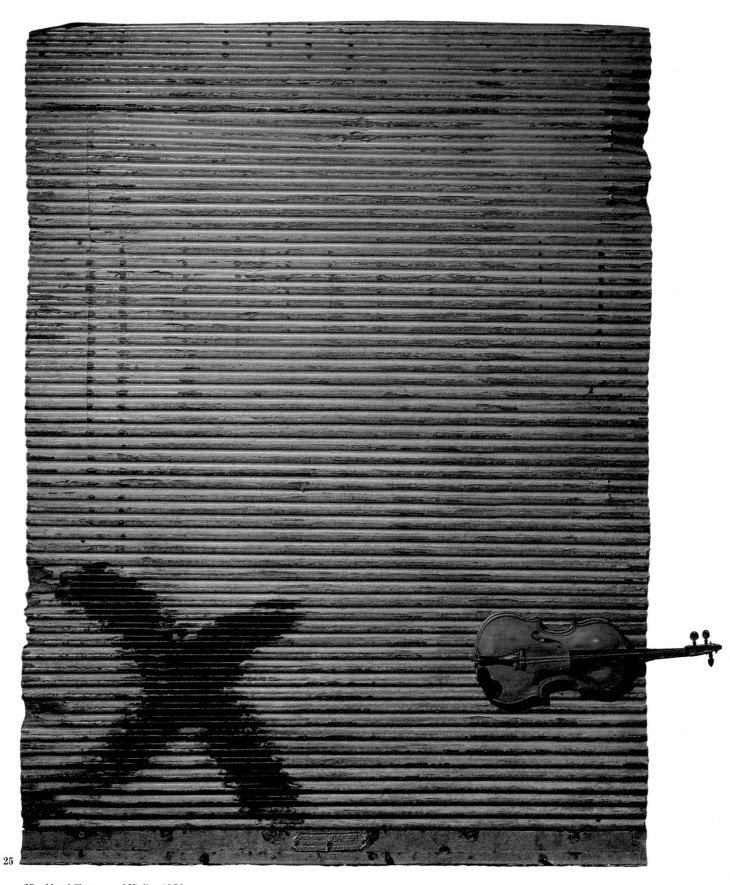

25

25 Metal Shutter and Violin, *1956.*
Object-assemblage, 200 × 150 × 13 cm.
Fundació Antoni Tàpies, Barcelona.

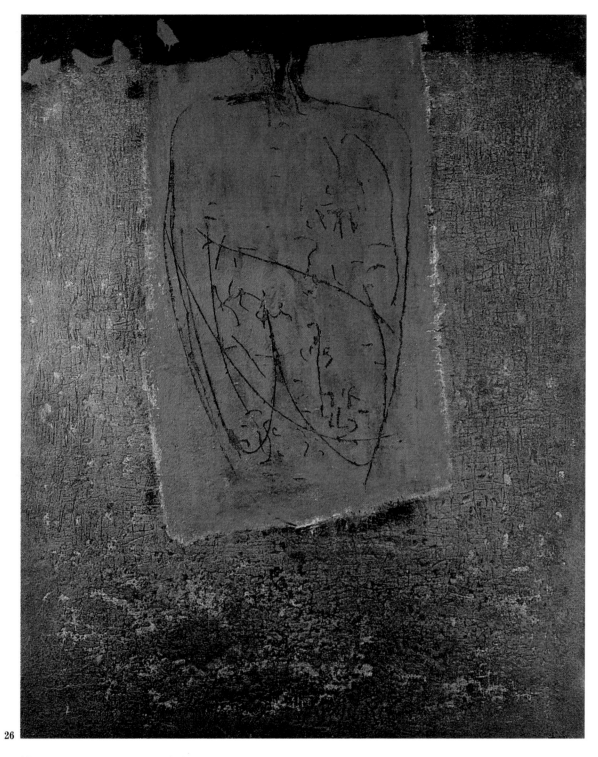

26

26 Figure-Landscape in Red, *1956.*
Mixed media on canvas, 162 × 130 cm.
Private collection, New York.

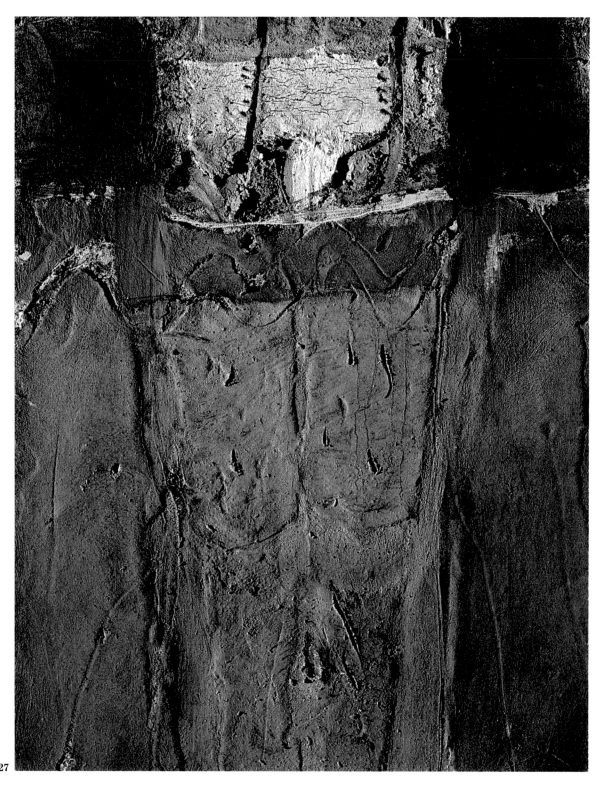

27

27 Crucified Form, *1959.*
Mixed media on canvas, 92.5 × 73 cm
Private collection, Weiden.

28 In the Form of a Chair, *1966.*
Mixed media on canvas, 130 × 97 cm.
Private collection, Barcelona.

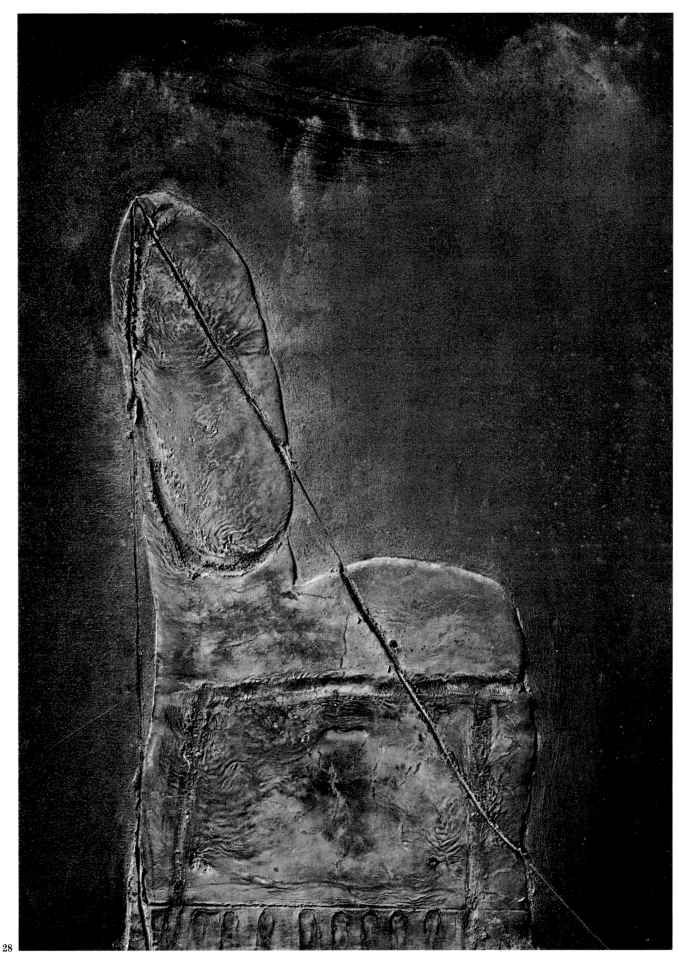

28

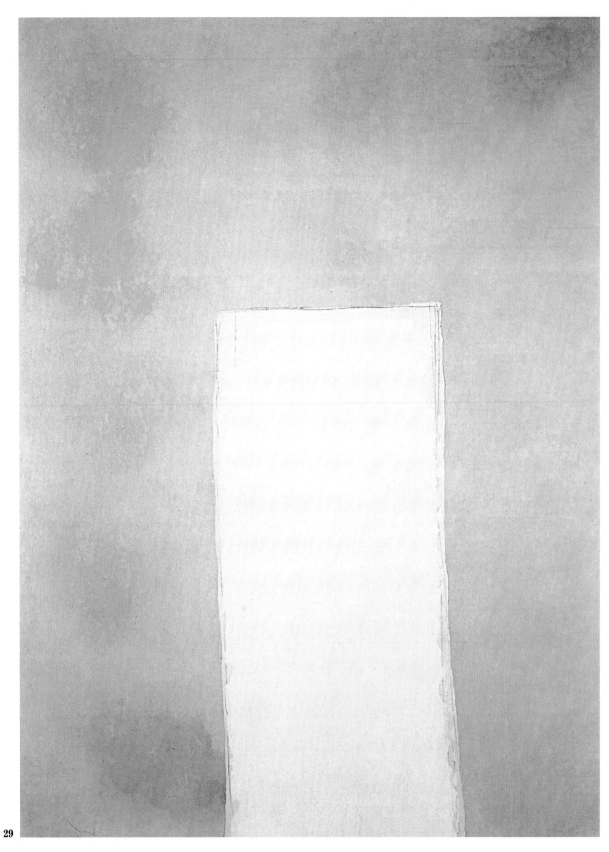

29 Large Door, *1969.*
Mixed media on canvas, 270 × 198 cm.
Private collection, Paris.

A painter of matter, icons and magical signs, Tàpies occasionally verges on abstraction, yet it would be mistaken to interpret this work as a mere play on chromatic effects. The door motif assumes esoteric meanings in Tàpies' œuvre, and as it appears in this particular composition, depicted in pale tonalities, can be related to the famous dark door-window painted by Matisse in 1914 that, in formal terms, also bordered on abstraction.

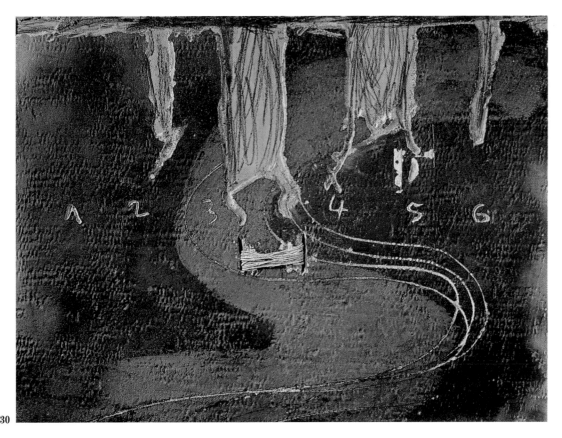

30 Cork Oak Grove, *1975.*
Mixed media on wood, 97 × 130 cm.
Private collection, Barcelona.

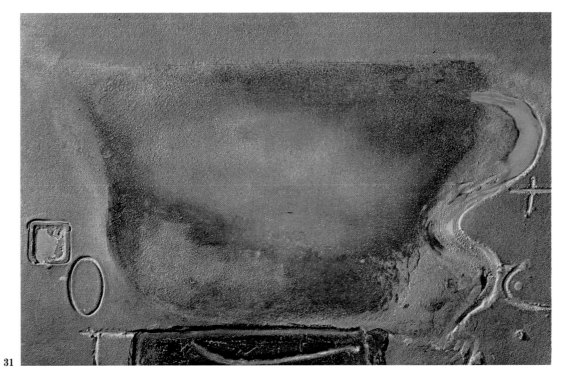

31 Cup, *1979.*
Mixed media on wood, 65 × 99.5 cm.
Private collection, Barcelona.

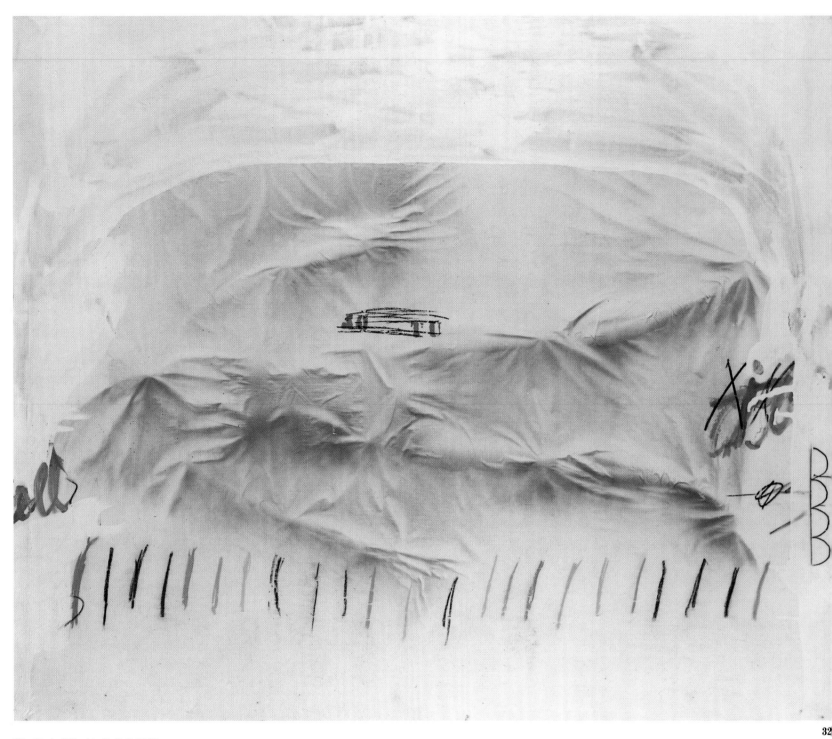

32 Body Effect in Relief, *1979.*
Mixed media on cloth, mounted on canvas, 195.5 × 232.5 cm.
Private collection.

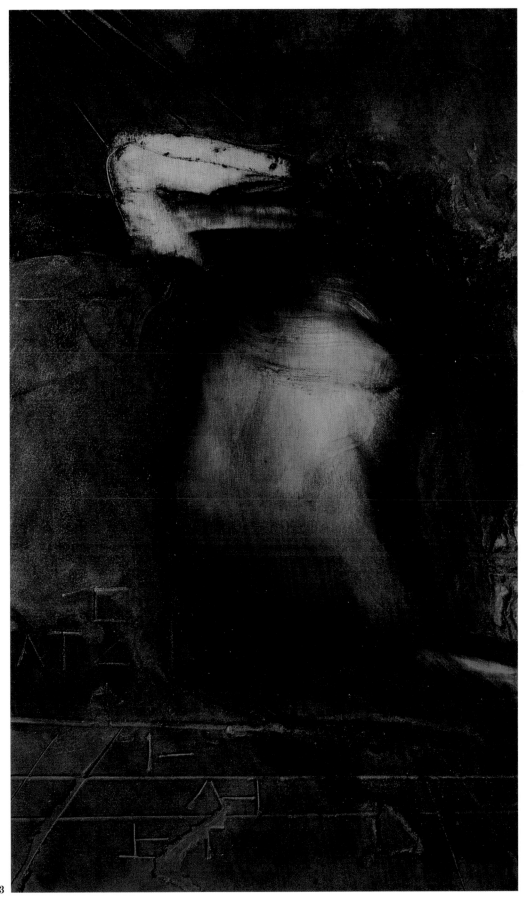

33

33 Back, *1981.*
Mixed media on wood, 162 × 97 cm.
Private collection, Barcelona.

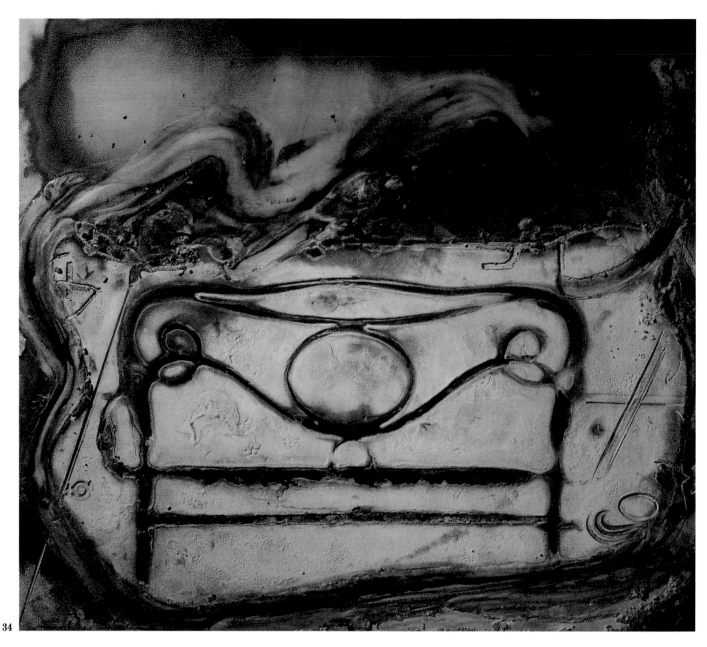

34

34 Sofa Imprint, *1981.*
Mixed media on wood, 170 × 195 cm.
Private collection, Barcelona.

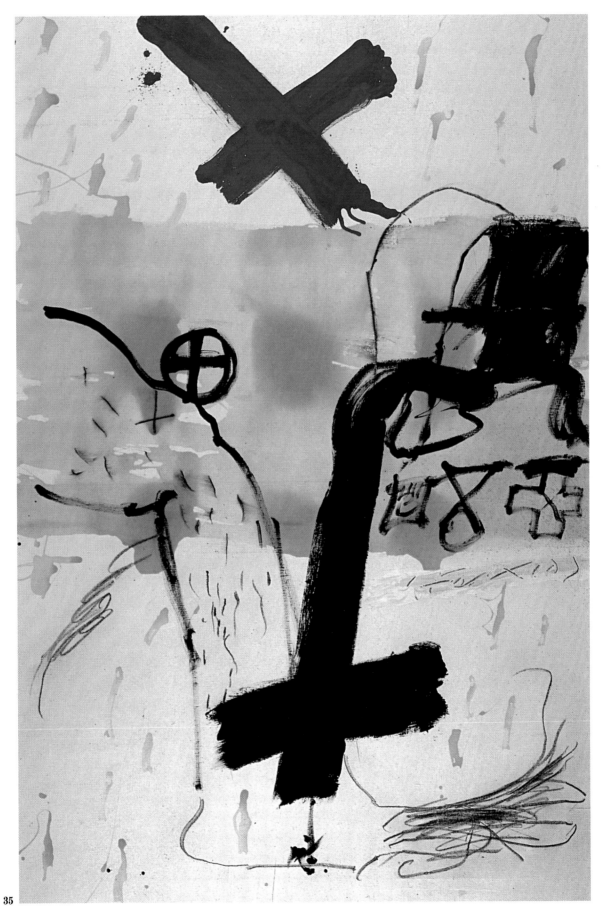

35 Leg and Red Cross, *1983.*
Paint and varnish on canvas, 195 × 130 cm.
Private collection.

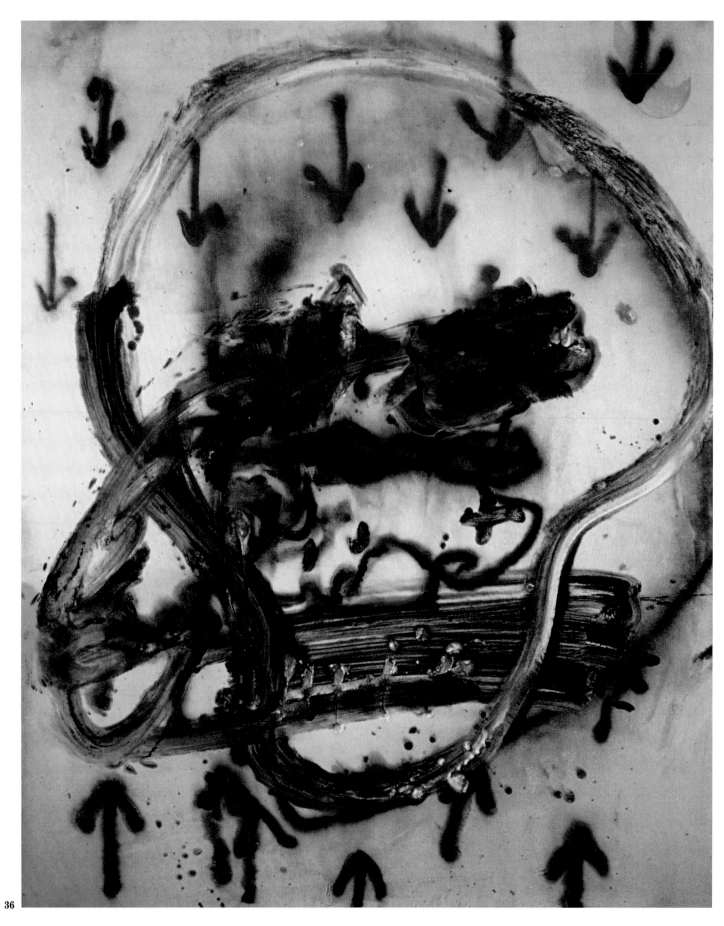

36

36 Skull and Arrows, *1986.*
Paint on wood, 162 × 130.5 cm.
Private collection, Germany.

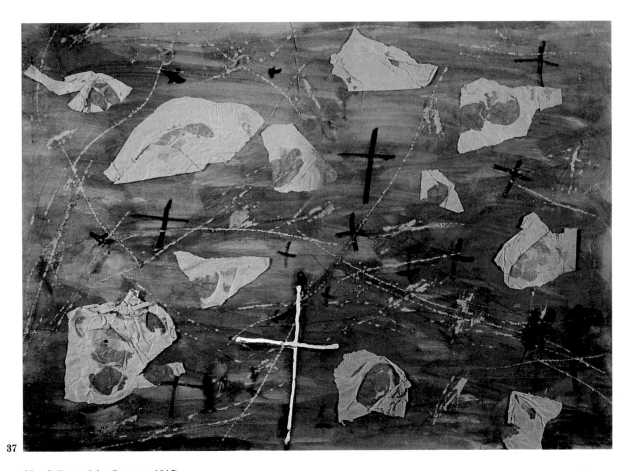

37 Collage of the Crosses, *1947*.
Paint and collage on cardboard, 52.5 × 73.5 cm.
Private collection.

Signs

Numerous signs — crosses, figures and letters — people Tàpies'
compositions, and while the artist does not provide us with precise
keys as to their meaning, he does suggest a general explanation for
them all, "When I work I don't analyse the reasons why I choose one
shape or another. I could of course do so subsequently. For many years
now I have been working almost automatically, unconsciously. Until
faced with the questions posed by critics, I made no attempt to
understand myself in any intellectual way […] I don't think it's
necessary for an artist to be continuously aware of his motivations.
When I produce a sign, an X, a cross or a spiral, I experience great
satisfaction. I realise that the work acquires a certain strength,
although I cannot understand where this lies. However, the placing of
letters in my works does obey precise motivations: A is a beginning, a
limit; T is the stylisation of the crucifix as well as being my own initial;
the cross is a meeting point of coordinates, etc. An A and a T together
could stand for my name and surname or my name and that of my wife,
Teresa."

38

38 Painting with Red Cross, *1954.*
Mixed media on canvas, 195 × 130.5 cm.
Private collection, Switzerland.

39 Hieroglyphics No. LXXIV, *1958–1960.*
Mixed media on canvas, 195 × 132 cm.
Private collection, Cologne.

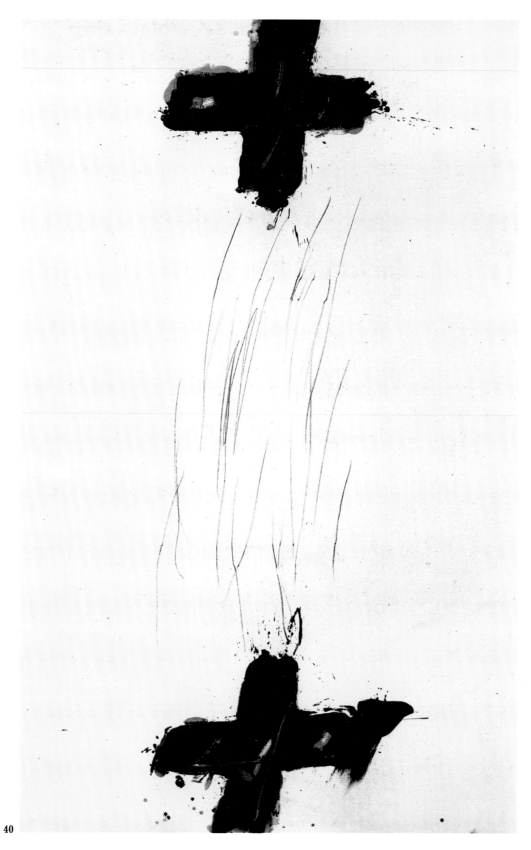

40

40 Two Black Crosses, *1973.*
Mixed media on canvas, 234 × 150 cm.
M. and Mme. Adrien Maeght Collection, Paris.

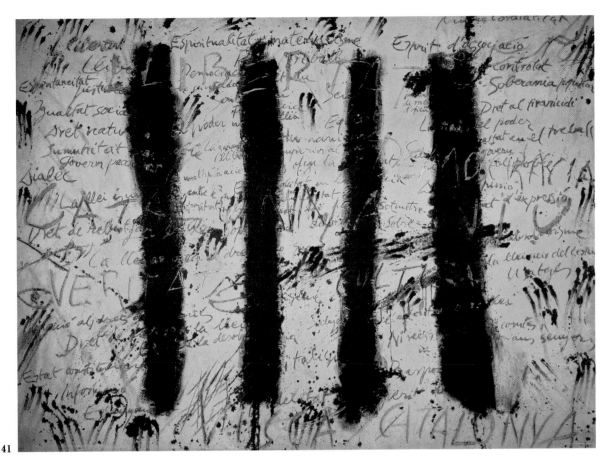

41 The Catalan Spirit, *1971.*
Mixed media on wood, 200 × 270 cm.
Private collection, Madrid.

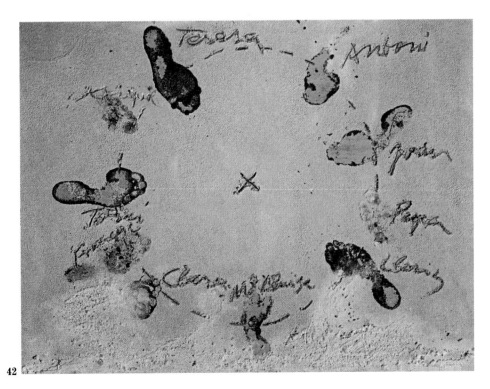

42 Sardana (Circle of Feet), *1972.*
Mixed media on wood, 97.5 × 130 cm.
Private collection, Barcelona.

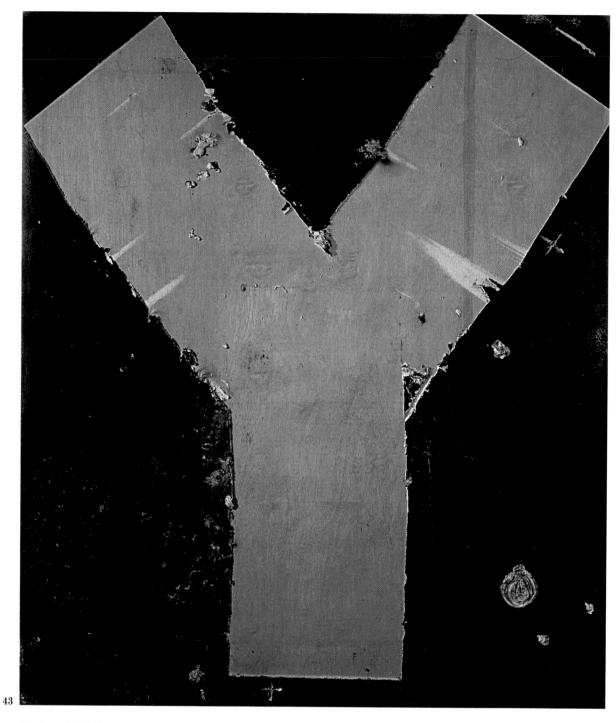

43

43 Large Y, *1980.*
Mixed media on wood, 195 × 170 cm.
Private collection, Valencia.

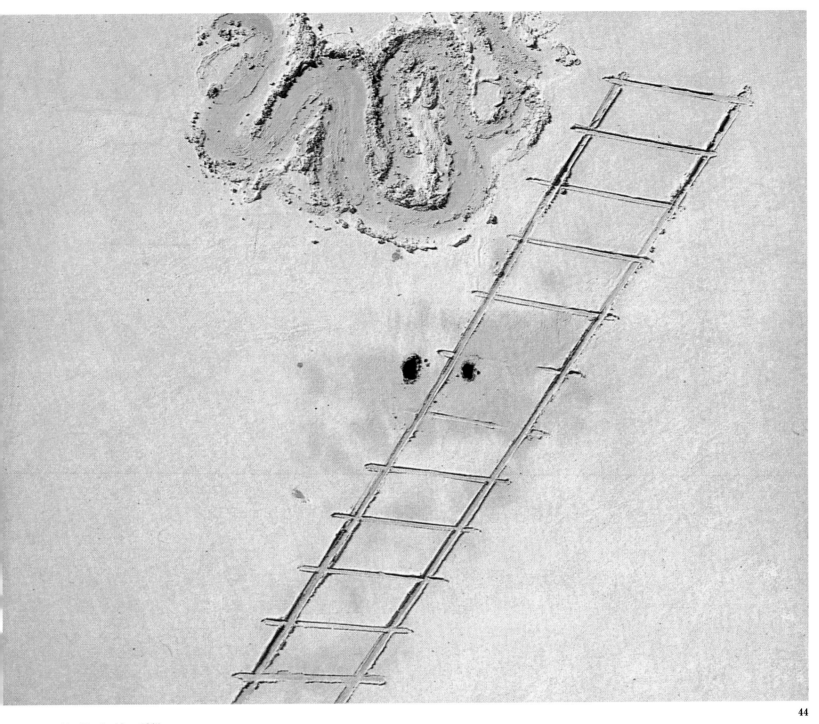

44 The Ladder, *1974.*
Mixed media on wood, 250 × 300 cm.
Telefónica Collection, Madrid.

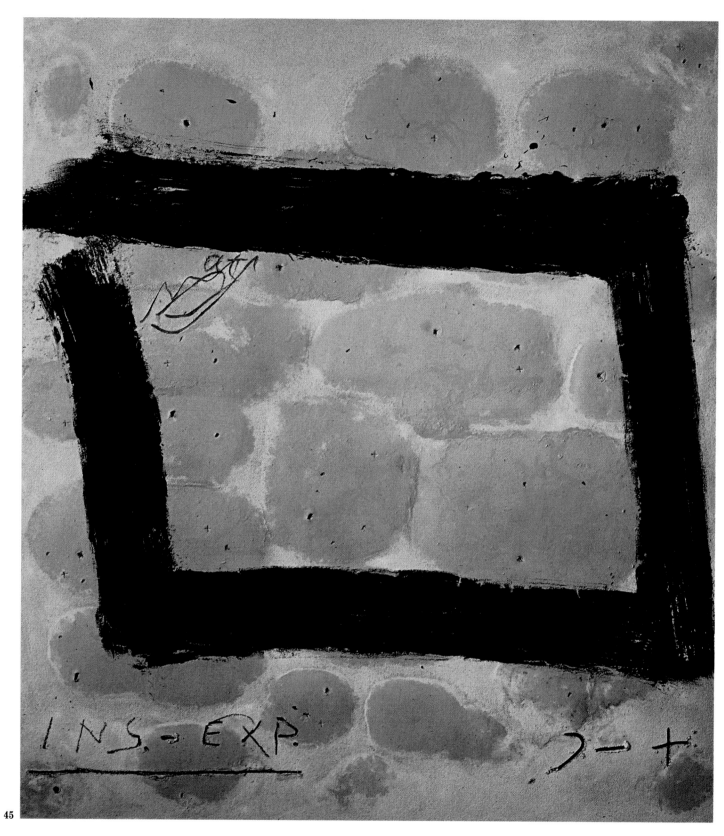

45

45 Breathing In-Breathing Out, *1991.*
Mixed media on wood, 225 × 200 cm.
Private collection.

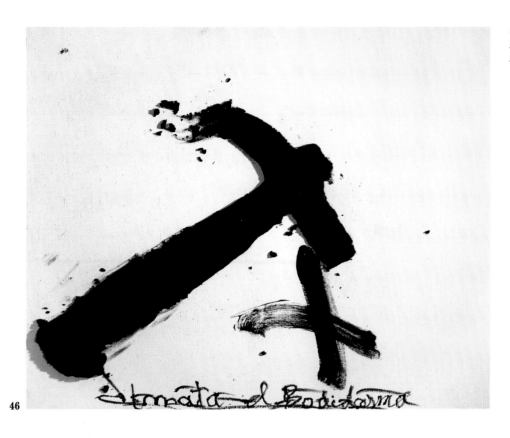

46

46 Hammer, *2002.*
Paint on canvas, 130 × 162 cm.
Private collection.

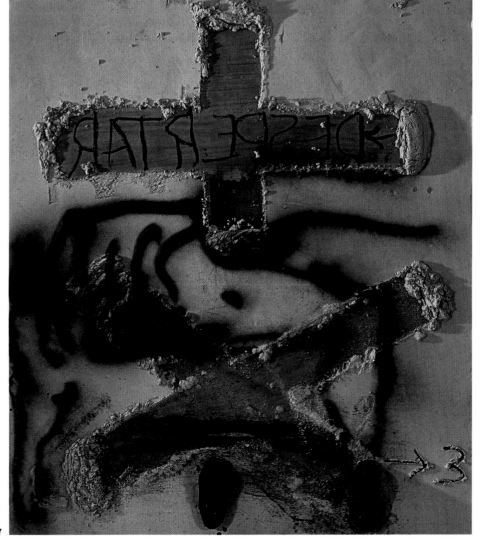

47

47 Awakening, *2002.*
Mixed media and collage on wood,
225 × 200 cm.
Private collection.

53

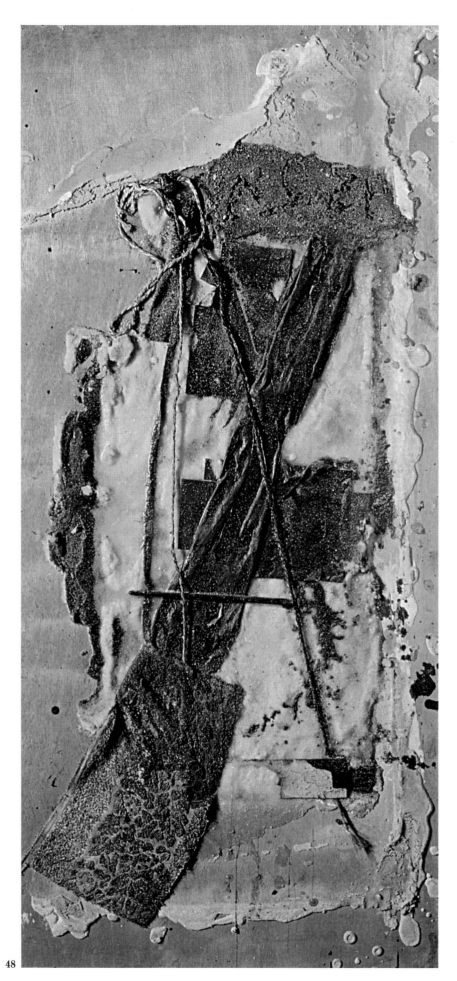

The Incorporation of the Object

Tàpies tells us, "I have always regarded the picture as an object instead of a window, as is usually the case in painting. This is why I add relief to its surface, and sometimes even work on a picture from the other side of the canvas — I transform a painting into a magical object that develops healing powers when it comes into contact with the human body, working as a talisman. I find all objects interesting, especially those of the Dadaists and Surrealists which produced a great impression on me and no doubt also exerted a notable influence on the collages produced by Schwitters, for instance."

48 Rags and Strings on Wood, *1967.*
Mixed media on wood, 110 × 53 cm.
Private collection.

48

54

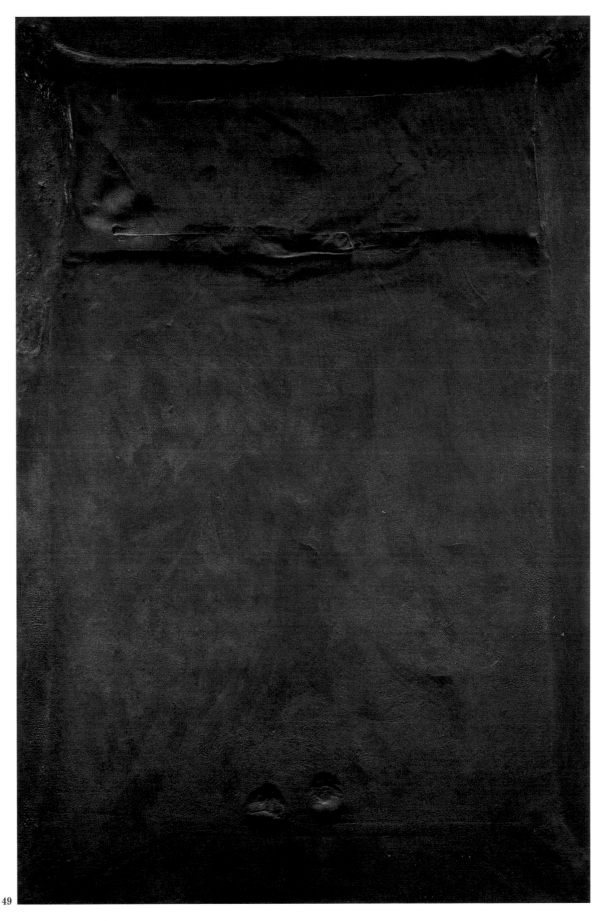

49 Brown Bed, *1960.*
Mixed media on canvas, mounted on wood, 195 × 130 cm.
Fundació Antoni Tàpies, Barcelona.

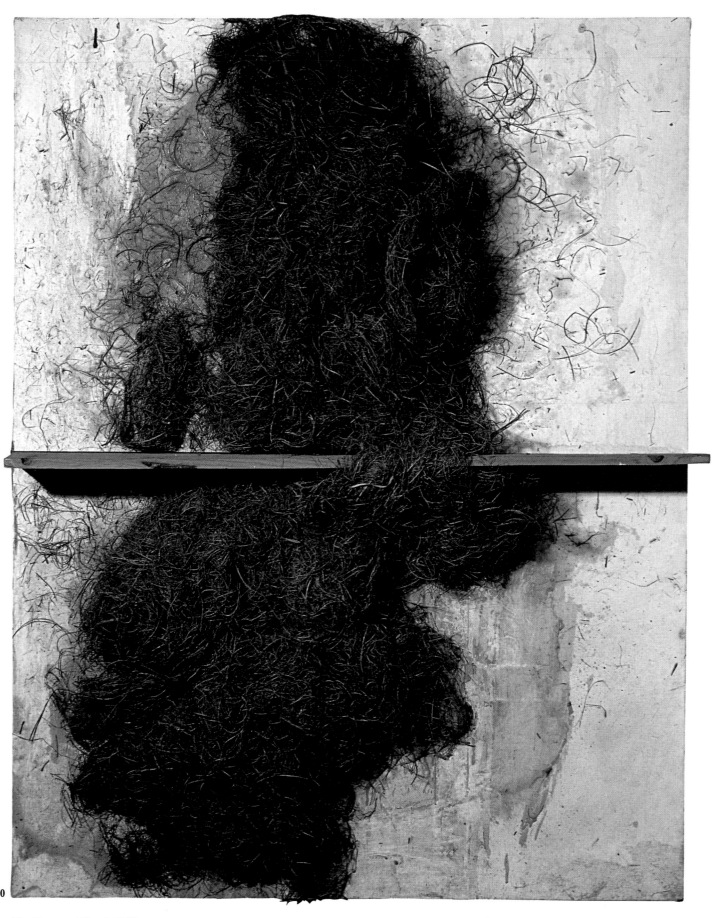

50 Straw and Wood, *1969.*
Assemblage on canvas, 150 × 116 cm.
Fundació Antoni Tàpies, Barcelona.

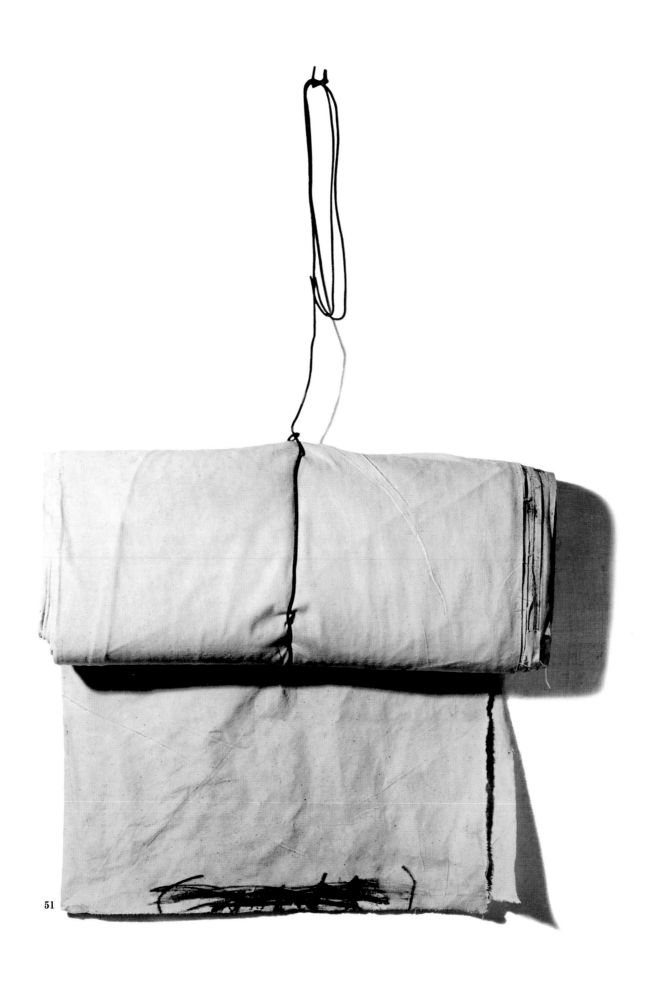

51 Piece of Cloth, *1973.*
Object-assemblage, 101 × 59 × 12 cm.
Private collection, Barcelona.

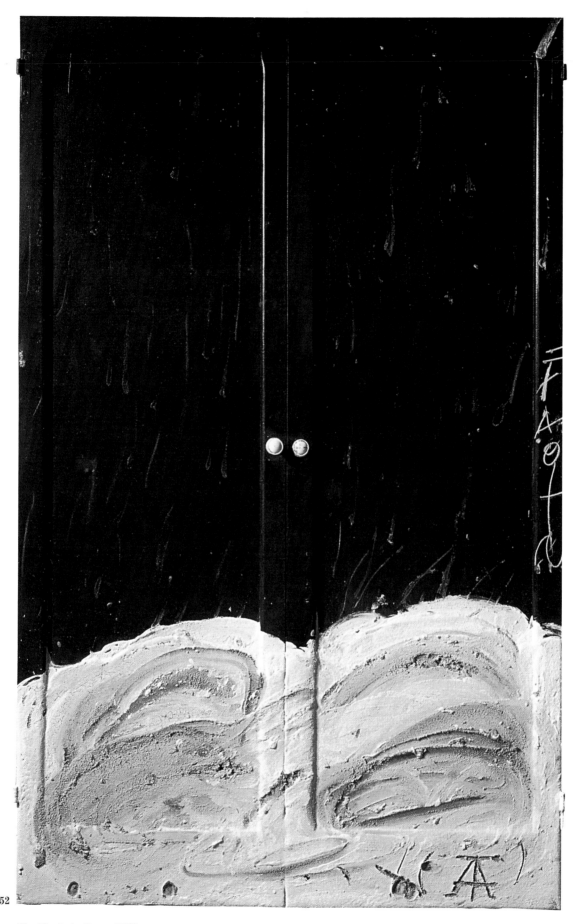

52

52 Wardrobe-Door, *1973.*
Mixed media on wood, 163 × 103 cm.
Private collection, New York.

53 Cane Effect in Relief, *1979.*
Mixed media on cloth, mounted on canvas, 139.5 × 112 cm.
Adrien Maeght Collection, Paris.

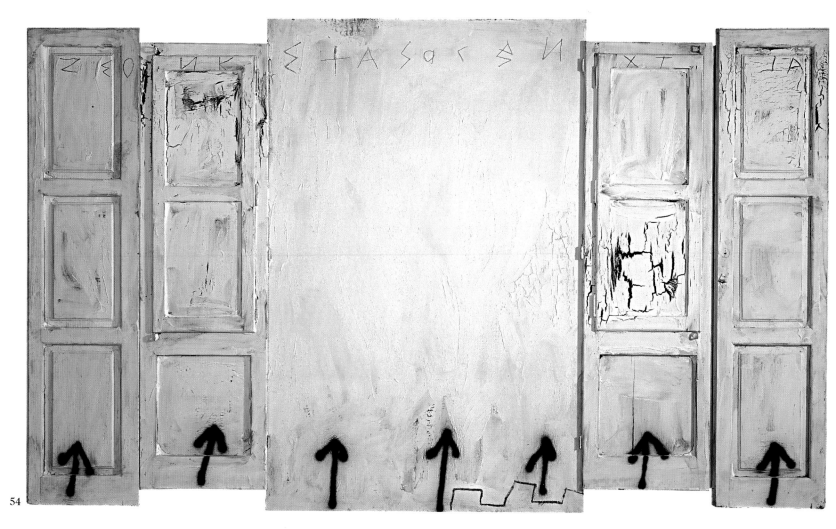

54

54 Doors and Arrows, *1987.*
Paint, varnish and assemblage on canvas, 195.5 × 330 cm.
Private collection, Barcelona.

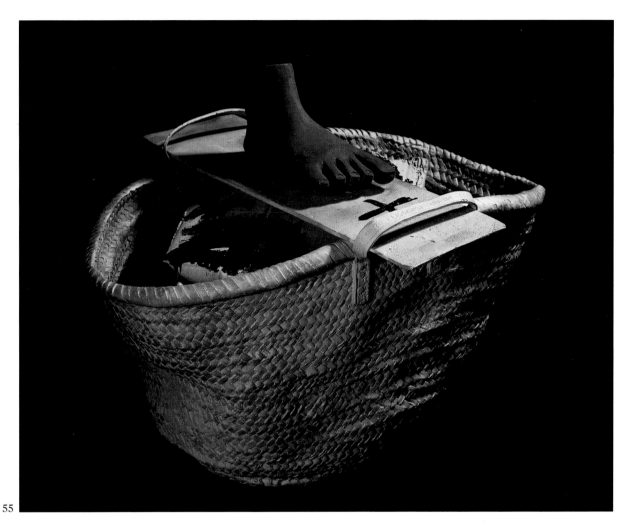

55

55 Foot and Basket, *1999.*
Paint on bronze, 39 × 48 × 52 cm.
Private collection.

List of Plates

45 Breathing In-Breathing Out, *1991. Mixed media on wood, 225 × 200 cm. Private collection.*

46 Hammer, *2002. Paint on canvas, 130 × 162 cm. Private collection.*

47 Awakening, *2002. Mixed media and collage on wood, 225 × 200 cm. Private collection.*

48 Rags and Strings on Wood, *1967. Mixed media on wood, 110 × 53 cm. Private collection.*

49 Brown Bed, *1960. Mixed media on canvas, mounted on wood, 195 × 130 cm. Fundació Antoni Tàpies, Barcelona.*

50 Straw and Wood, *1969. Assemblage on canvas, 150 × 116 cm. Fundació Antoni Tàpies, Barcelona.*

51 Piece of Cloth, *1973. Object-assemblage, 101 × 59 × 12 cm. Private collection, Barcelona.*

52 Wardrobe-Door, *1973. Mixed media on wood, 163 × 103 cm. Private collection, New York.*

53 Cane Effect in Relief, *1979. Mixed media on cloth, mounted on canvas, 139.5 × 112 cm. Adrien Maeght Collection, Paris.*

54 Doors and Arrows, *1987. Paint, varnish and assemblage on canvas, 195.5 × 330 cm. Private collection, Barcelona.*

55 Foot and Basket, *1999. Paint on bronze, 39 × 48 × 52 cm. Private collection.*

Selected Bibliography

GLORIA MOURE. *Tàpies. Objetos del tiempo*. Ediciones Polígrafa, Barcelona, 1994.

ANDREAS FRANZKE. *Tàpies*. Ediciones Polígrafa, Barcelona, 1992.

VICTORIA COMBALIA. *Tàpies*. Ediciones Polígrafa, Barcelona, 1989.

ROLAND PENROSE. *Tàpies*. Ediciones Polígrafa, Barcelona, 1986.

Source of the quotations

BARBARA CATOIR. *Conversaciones con Antoni Tàpies*. Ediciones Polígrafa, Barcelona, 1989.